FILMMAKING
TERMS POCKETBOOK
GLOSSARY

Published by Library Tales Publishing, Inc.
www.LibraryTalesPublishing.com
www.Facebook.com/LibraryTalesPublishing

For general information on our other products and services, please contact our Customer Care Department at 1-800-754-5016, or fax 917-463-0892. For technical support, please e-mail Office@Librarytales.com

Library Tales Publishing also publishes its books in a variety of electronic formats. Every content that appears in print is available in electronic books.

ISBN-13. 978-0692232941
ISBN-10. 069223294X

LIBRARY TALES PUBLISHING

WELCOME

Welcome to *The Filmmaking Term Pocketbook Glossary*. This pocket size glossary contains over 3,000 "must know" filmmaking terms commonly used during pre-production, on set and in post. This book contains detailed descriptions for the most popular filmmaking terms, including terms relating to grip, lights, cinematography, screenwriting, visual effects and film distribution. This handy pocketbook is a "must" on-set tool which can prove useful for filmmakers, film producers, actors and any person who wants to get involved in the exciting world of film production.

CONTENTS

1&2. Frequently used to refer to the first and second mark of a camera move.

1.25:1. A 5:4 aspect ratio format used for early television.

1.33:1. A standard 4:3 aspect ratio format used for traditional television.

1.375:1. A standard Academy Ratio for 35mm film, standardized in 1932.

1.43:1. The (projected) 70mm IMAX film aspect ratio format.

1.6:1. The 16:10 (or 8:5) ratio used for most PC monitors.

1.77:1. The most common (16:9) widescreen aspect ratio format.

1.85:1. A flat widescreen cinema aspect ratio.

2.39:1. An ultra-wide cinema standard aspect ratio.

10 Bit. The number of color levels available in a digital signal.

1080. A common HD resolution, 1920x1080.

180 Degree Rule. A basic filmmaking guideline referring to the camera's position in a scene. The 180 Degree Rule states that two characters in a scene should always have the same left/right relationship to each other. When the 180 degree rule is broken (also called "crossing the line"), a character who was originally facing left in a scene is suddenly facing right.

2.3/3.2 Pulldown. The post-production practice of converting 24fps film to interlaced 30 fps NTSC.

24 fps, 24 Frames-per-second. The standard frame rate for film.

2-Pop. An audible tone marking an audio/picture sync point.

3-Point Edit. In digital video editing, the three point edit is a technique used to add a clip into a timeline track by setting three edit points.

3,200K. The color temperature of tungsten light.

3D. A stereoscopic technology that creates the illusion of three dimensional depth.

3DS-Max. A computer animation software used in games and feature films.

4.2.2. A digital color sampling rate.

4:3. Standard aspect ratio used for television (1.33.1).

4.4.4. A digital color sampling rate providing more color information than 4.2.2.

480. A resolution of either 720x480 or 704x480 pixels.

48fps. An experimental frame rate used on *The Hobbit* films. See High Frame Rate.

4K. The dominant projection standard. 4K is a term used to describe Ultra-HD footage with horizontal resolution of approximately 4,000 pixels. Precise size depends on the aspect ratio.

5,400K. Daylight color temperature.

5.1 Channel Digital Sound. The term used to describe a six channel surround sound audio system generally composing of front left, front right, center, surround left and surround right.

70/30 Deal: A film distribution deal in which the distributor recoups predefined expenses first and the balance is then split 70/30. (70% goes to the distributor and 30% to the producer).

7.1 Surround Sound. An eight-channel surround audio system adding two additional speakers to the 5.1 Channel Digital Sound configuration.

720p. A high definition resolution of 1280x720 pixels, the "p" stands for progressive.

8 Bit. The number of color levels available in older digital video signal.

8mm, Standard-8, Double 8. An motion picture film format (eight millimeters wide) developed by Kodak in 1932.

8 Bit. The number of color levels available in older digital video signal.

8mm, Standard-8, Double 8. An motion picture film format (eight millimeters wide) developed by Kodak in 1932.

A.D. Converter, ADC, Analog-to-Digital Converter. An electronic device used to convert electrical analog signal into a digital signal.

A/B Rolls. Two or more rolls of motion picture film.

Abby Singer. Known as the Martini Shot. The Abby Singer is the second-to-last shot of the day. Named after renowned production manager Abby Singer.

Aberration, Lens Aberrations. An image distortion or color rendition caused by a limited-performance lens.

Above The Line Costs. In film budgets, the term is used to represent the creative costs of producing the film, such as story rights, cost of hiring a director, writers, producers, principal cast, and other creative costs. Everything else falls under 'below the line' expenses.

Abstract. A sub-genre of experimental film. (*Prospero's Books {1991}, Possession {1981}, Gozu {2003}, etc.)*

Academy Aperture. The standard 35mm film 4.3 aspect ratio (1.33:1) established by the Academy of Motion Picture Arts and Sciences in 1932.

Academy Awards, Oscars, A movie awards event hosted annually by the Academy of Motion Picture Arts and Sciences in Hollywood to celebrate achievements in various motion picture categories such as sound, screenplay, makeup, etc.

Academy Leader. A countdown clip used to give the projectionist enough time to run the machine for the picture to start.

Academy of Motion Picture Arts and Sciences. An organization dedicated to the advancement of the film industry's arts and sciences, overseen by representatives from each branch of the film industry. *(i.e. The Board of Governors)*

Accent Light. A controlled light unit that illuminates an architectural detail.

Access Letter. A letter provided by a laboratory to a film distributor in which the lab promises to honor an order regardless of any other debts already owed for the project.

Accountant. The person responsible for managing the financial aspects of a film production.

ACE, American Cinema Editors. An honorary society of film editors who are voted into membership on the basis of their professional achievements. Not to be confused with a labor union.

Acetone. A natural chemical used to produce film cements and clean film splicing equipment.

Acoustics. The science of sound wave transmission.

Act. A main division within film plots. Beginning (act 1), middle (act 2), end (act 3).

Action Cut. A picture cut that uses on-screen motion (action) to cover the transition, making the action appear continuous and uninterrupted.

Action Safe Area. A screen area where elements are guaranteed to be visible.

Action. Any movement captured on film that moves the story forward.

Action, Call. The word called out by a director at the start of a new take.

Action, Film. A popular movie genre. *(Transformers, Spiderman, Planet of the Apes, The Hunger Games, etc.)*

Actor. A man or woman who play the role of a character on film.

Adaptation. A film or TV show that has been adapted from a written work, typically a novel or a play. *(Harry Potter, The English Patient, The Hunger Games)*

Additional Camera, B Camera. An additional camera operator often needed for covering shots from different angles or filming secondary scenes and inserts. ^{See Inserts.}

Additive Color. A color created by mixing the three primary colors: red, green, and blue.

Adjusted Gross Deal, Gross Deal. A common film distribution deal wherein the producers receive an advance (upfront payment) in addition to a portion of the film's net profits.

Adobe After Effects. A digital motion graphics, visual effects, and compositing software popular among indie filmmakers for producing low cost visual effects.

Adobe Premiere. A timeline-based NLE video editing application used by both indie and professional filmmakers.

Adobe RGB. A color space containing a wider range of color than the more frequently used sRGB color space.

Adobe Systems. A software company creating multimedia applications for use in film productions. *(After Effects, Premiere, Audition, Speedgrade, Story, etc.)*

ADR Editing. The process of editing and mixing sound during an ADR session. See ADR.

ADR. Abbreviation of Automatic Dialogue Replacement.

Advance Screener. A Screener sent in advance to a film critic or Academy voter. See Screener.

Advance. A payment provided by a film distributor to secure a film's distribution rights.

Aerial, Aerial Shot. A high angle shot taken from a plane, helicopter, drone or crane.

Agent. A person responsible for negotiating and securing contracts on behalf of a talent (actor, director, etc.). Agents typically handle the talent's business and often take part in selecting or recommending roles for their client.

Air. Compressed canned air

AKS. *"All kinds of stuff"*

Alan Smithee. The sole pseudonym that the Directors Guild of America allows directors to use when they wish to disassociate themselves from a film.

A-List. Refers to a non-official list of famous actors, producers, directors, and writers who command top dollars and are well-recognized or celebrated in the media.

Alpha channel. An image channel that controls opacity. White portions of the image are visible, black portions are invisible (masked).

Alternate ending. The originally planned ending for a film, replaced with the one used upon release.

Ambiance Sounds. The sounds generated by the environment of a space or a location. *(e.g. birds in the forest, traffic in the city, ocean waves, etc.).*

Ambient Light. The available light in a natural environment.

Anachronism, Film Flubs, Goofs. A production element or artifact captured on film by mistake and visible when the film is released. Not to be confused with blooper, which is cut out during editing. *(e.g. at the end of the color-naming scene in Reservoir Dogs, the boom mic is clearly visible in the shot)*

Analog Recording. A means of recording analog signal for either audio or video.

Analog Video. A signal transferred by an analog signal (S-video). It has lower quality than that of a digital video. *(SDI, DVI, HDMI, DisplayPort)*

Anamorphic Lens. A compound lens which affects the way an image is projected onto the camera sensor.

Anamorphic Widescreen Format. The process of horizontally compressing a widescreen image to fit into a storage medium with a narrower aspect ratio. The image is later re-expanded to its original widescreen format.

Ancillary Rights, Secondary Rights. A clause in distribution contracts which give the filmmakers a percentage of the profits derived from merchandising revenue. *(These include TV spin-offs, remakes, publishing deals, toys, action figures, posters, soundtrack sales, etc.)*

Angel. A private investor. See Investors.

Angle of View. The field size covered by a lens, measured and calculated in degrees. The focal length of a lens will determine its Angle of View.

Angle On. To direct the camera to move and focus on a particular subject.

Angle, Camera. The position of the camera in relation to its subject. *(Low angle, high angle, eye-level, bird's eye, canted, oblique, etc.)*

Animation. The illusion of motion created by manipulating individual frames of still-images and playing them back at a particular frame rate. This is in contrast to filming naturally-occurring action in real time (live-action).

Anime. A style of animation rooted in Japanese comic books.

Answer Print. The first ready-to-see film print produced by a lab. Once approved, it is sent to duplication and distribution. Also known as the First Trial Print.

Antagonist. A character or an object who represents the opposition, obstacle, threat, or problem with which the protagonist must contend.

Anthology Film. A film composed of several short films. *(e.g. The Red Violin {1998}, Invitation to the Dance {1956}, Please Do Not Disturb {2010}, etc.)*

Anti-aliasing. A digital process for smoothing jagged lines in an image.

Anti-climax. An unsatisfactory end to a thrilling or inspiring series of events.

Anti-hero. A central character who lacks conventional heroic qualities. *(e.g. Eric Draven in 'The Crow', Mickey & Mallory Knox in 'Natural Born Killers', Severus Snape in 'Harry Potter', etc.)*

Aperture, F-Stop. A measurement of the width of a camera lens opening that regulates the amount of light passing through and contacting the film or sensor. Not to be confused with T-Stop. See *T-Stop*.

Apple Box. Sturdy, solid wooden boxes used by grips to support heavy weights and large objects.

APS-C. The size of the digital imaging sensors used in most DSLRs.

Arc Shot. A shot in which the camera rotates around the subject in a circular motion.

Arc. A lighting unit producing light from an electrical arc.

Arm, Grip Arm. A metal rod attached to a C-Stand.

Armourer, Weapon Master. Responsible for all weapons (guns, swords, etc.) and armor props on set.

Art Department. A major department in charge for the visual, artistic look of the film. Often including the Art Director, Set Designers, Set Decorators, Construction Coordinator and others.

Art Director. The person responsible for the design, look, and feel of the film's sets.

Arthouse Film. A film genre encompassing artistic and experimental themes. *(e.g. The Tree of Life {2011}, Wild Strawberries {1957}, The White Ribbon {2009}, City of God {2002}, etc.)*

Artifact. An unwanted visual effect caused by a technical error or equipment malfunction. It can also be an undesired (or desired) element in an image as a result of digital processing or shooting environment.

ASA. The American Standards Association.

ASA, Film Speed. The light-sensitivity index of motion picture film or digital camera sensors.

ASC, American Society of Cinematographers. An educational, cultural, and professional organization. Often confused with a labor union or a guild.

ASCAP. Abbreviation for The American Society of Composers, Authors and Publishers.

Aside. A term used to describe the point when a character breaks the imaginary "fourth wall" and speaks directly to the viewers or looks directly at the camera to deliver a message.

Aspect Ratio. The proportion of the picture width to height. *(1.33.1, 1.66.1, 1.85.1, 2.35.1, etc.)*

Asperity Noise, Hiss. Audible background noise caused by surface imperfections in the medium.

Aspheric lens. A lens whose complex surface profiles can correct or reduce optical aberrations found in simpler lens designs, producing better aesthetic and sharper edge definitions.

Assemble. The first stage of the editing process in which the editor organizes the shots in a particular sequence, typically in accordance with the order of the script.

Assignment By Way of Security. Securing film financing by granting temporary copyrights to the financier as a way of guaranteeing loan repayments.

Assimilate Scratch. Real time color correction and grading software.

Assistant Art Director (1st, 2nd, 3rd). Art Department crew members responsible for carrying out the Art Director's instructions.

Assistant Camera, AC. A camera crew member assisting the camera operator.

Assistant Director, AD. The director's right-hand, who handles logistics, tracking schedules, and other important tasks on behalf of the director.

Assistant Editor. Responsible for providing assistance to the chief editor.

Assistant Location Manager. Works as an assistant to the Location Manager.

Assistant Production Manager. An assistant to the Production Manager (UPM).

Associate Producer. Works under the supervision of the film's producer.

Asynchronous Sound. A mismatched audio track, not precisely synchronized with the image.

Atmosphere. Another word for weather or special effects. *(Smoke, fog, steam, etc.)*

ATSC Standard. A set of broadcast standards developed to include both HD and SD formats and replace the older analog NTSC standard.

Attenuate. The process of reducing signal strength.

Audience. The viewers of a film. They are often segmented or categorized for the purpose of determining a film's marketing strategy.

Audio Bridge. Audio that crosses over from one shot to another, which eases the transition and connects the two shots together.

Audio. The sound portion of a film.

Audition. (1) A short performance given by an actor or actress to showcase their ability to play a character in the film. (2) A digital audio workstation from Adobe Systems used for audio editing and mixing. See *Adobe Systems*.

Auteur. A term used to describe a filmmaker whose personal style dominates over his/her work.

Auto Conform. The automated process of producing a time-coded EDL file (Edit Decision List) from an offline editing system to replace Proxies with broadcast quality files. See *Proxies*.

Autodesk Flame. A premium visual effects software used to create real-time color grading and VFX.

Autodesk Maya. A 3D animation software used in feature films and animations.

Autodesk Smoke. A high-end VFX software.

Autodesk. A leading company in 3D applications. Producing software like 3DX-MAX, Maya, Flame, Smoke, etc.

Autofocus. A camera function in which the lens keeps a subject in focus without the need for manual adjustment. This function is useful for still photographs.

Automated Dialogue Replacement, Looping, ADR. The process of re-recording lines of dialog or other human sounds in a recording studio and syncing it with the actor's lips as if it was recorded on location. Used to replace lines of dialog not properly captured during filming.

Available Light. Any light source which is naturally available.

Average Metering. An in-camera mode that allows the camera to use the current light values such as highlights, shadows, and mid-tones and combine them to establish a final exposure setting.

AVID. Manufacturer of the popular non-linear editing system "Avid Media Composer". An Avid Editor is an editor who is proficient in the Avid editing software.

AWB, Auto White Balance. In-camera function that automatically adjusts the scene's color balance to a neutral color regardless of lighting conditions.

Axis of Action. See the 180 Degree Rule.

B-Movie. The second movie in a double-feature billing; generally a low-budget film involving monsters, horror, and crime. *(Some famous examples are The Giant Claw {1957}, It's Alive {1974}, X: The Man with the X-Ray Eyes {1963}, Mac and Me {1988}, etc.)*

BBFC, The British Board of Film Classification. The institution responsible for rating and certifying films in the UK.

Babies, Baby Sticks, Baby Legs. Terms used to refer to short tripods.

Baby Plate. A metal plate designed to mount baby fixtures to walls, floors, and apple boxes.

Baby. Any 1K-5K lighting unit.

Back In. Means "back to work", after a break.

Back lot. An open, undeveloped part of a studio property (the back lot) used to construct open sets for filming nature or outdoors scenes.

Back projection. A technique whereby live action is filmed in front of a screen projecting the background action. Used for car driving scenes.

Backdrop. A large background used to represent a location in a scene, such as a view seen from a window, a specific landscape, mountains, ocean, etc.

Background Artist, Matte Artist. A person responsible for designing backgrounds.

Background Music. Music used to establish an atmosphere in a scene.

Backlight. A light mounted behind a subject for the purpose of illuminating their hair and shoulders, and separating them from the backdrop and creating an illusion of depth.

Balance. A term used to define the composition and the aesthetic quality of a film or scene.

Balanced Audio. A floating light source used to illuminate parts of a shot without running wires or using a light stand.

Balloon Light, Helium Daylight Balloon, Self-Illuminated Balloon. A floating light source used to illuminate parts of a shot without running wires or using a light stand.

Banned Film. An effort by an international government or film ratings board to block a film from being released for political, religious, moral, or social reasons.

Bar Sheets, Exposure Sheets. In film animation, a bar sheet is a breakdown of recorded dialogue and the number of frames needed for each shot.

Barn doors. Folding black metal doors mounted on all four sides of a light source, used to control the direction of the light.

Barney. A sound-suppressing blanket placed over loud objects on the set (motion picture cameras).

Barrel Distortion. An optical distortion common in cheap wide-angle lenses and DSLRs that cause the images to be distorted.

Based on a True Story. A film narrative that has some basis in real historical events. *(The Aviator {2004}, 127 Hours {2010}, The Fighter {2010} Argo {2012}, The Wolf of Wall Street {2013}, etc.)*

Bazooka. A grip stand.

BCU, Big close-up. A shot in which the face occupies most of the frame.

Beat. An actor's pause before speaking or acting, a beat usually lasts for one second.

Beaver Board. A 2K pigeon on an apple box.

Bed. Background music used with narration.

Beefy Baby. A heavy-duty stand (commonly 2K) without wheels.

Beep. A short sound tone used to help synchronize audio and video.

Behind the Scenes, BTS. The events and circumstances behind the making of a film, commonly captured on camera and distributed as a bonus feature.

Below the Line Costs. Below the Line refers to the physical production costs not included in the Above the Line section of the budget. *(e.g. Cost of materials, film stock, rentals, music rights, salaries, contractors, development, post production, visual effects, publicity, trailer, etc.)*

Best Boy Grips (Light, Grip, Electric). The chief assistants to their department heads, the Gaffer and Key Grip. They act as department foremen, responsible for the day-to-day operations of the light and grip departments.

Best light. A color correction term used to refer to a single grade performed in one pass with one color correction setting that applies to the whole sequence, as opposed to an individual scene-by-scene color correction.

Beta. Betamax video tape.

Betacam. An analog component video format using Beta tapes for SD broadcasting.

Billing. The process of determining credit placement for actors, directors, and producers in a film's opening credits, closing credits, publicity materials, and on theatre marquees.

Bin. The storage containers used to organize motion picture film cuts and sound stock. In digital editing, it is commonly referred to as the virtual bin in which editors store clips for use in a sequence.

Biopic. A biographical film. *(Capote {2004}, The Elephant Man {1980}, The Social Network {2010}, American Splendor {2003}, The Aviator {2004} etc.)*

Bit part. A minor acting role with very few lines or acting. *(Sarah Silverman on 'Seinfeld')*

Bit. The smallest possible unit of digital information. Digital images are often described by the number of bits used to represent each pixel.

Biz. A term used in reference to "the business", or "show business".

Black and Code. Prerecorded tapes containing blank, time-coded data. Also known as Striped Stock.

Black and White, B&W. A film without colors, except for black, white, and shades of gray. Prior to the invention of color film stock, all films were shot in black and white.

Black Comedy, Dark Comedy. A humorous film that makes fun of an otherwise sad or dark subject matter.

Black Crushing. A color correction term referring to the intentional loss of details in the shadows (low light, blacks) by adjusting the contrast and turning light shadows darker. A common look used in Noir films and/or dark scenes.

Black Level Signal. A term used to reference the level of brightness within the part of the image that has absolutely no light in it, i.e. pure black.

Black Wrap. A black aluminum foil used for wrapping lights and controlling light spill.

Blacklisting. A term used in the late 40s- 50s to describe the discrimination and employment ban of various filmmakers, directors, producers, and actors in Hollywood based upon the belief that they had connections to communism. *(e.g. Walter Bernstein, Lee Grant, Cliff Carpenter, Marsha Hunt , etc.)*

Blaxploitation. A popular film genre which emerged in the 1970s and is considered to be an ethnic sub-genre of exploitation films. Originally produced for black audiences. *(e.g. Blackenstein {1973}, Mandingo {1975}, Shaft {1971}, Blacula {1972}, etc.)*

Bleach Bypass/Reduction. A processed film look resulting in reduced saturation and increased contrast.

Blimp. A sound-suppression housing unit for noisy film cameras designed to prevent sound equipment from picking up camera noise.

Blip Tone. A sync sound-pop used to establish a 'sync' point.

Blockbuster. An impactful, commercially-successful film, typically produced on a massive scale.

Blocked Shadows. A term used to describe the lack of shadow detail in an image. Generally, it is the result of underexposure or of a low resolution imaging sensor.

Blocking. A rehearsal practice which determines the movement of actors and the camera in a scene, as well as the consequent placement of lights, grip, and gear.

Blonde, Mighty. An open face 2K lighting unit.

Blood Capsules. Fake blood pills.

Bloop. A distinct sound produced by an audio system when a film splice passes the photo cell to which the amplifier is connected.

Blooper. An unused take usually an on-camera mistake or a flop by a cast-member or crew, known to be either embarrassing or humorous. Blooper-reels are a compilation of bloopers often used as a DVD bonus feature or appear during the end-title-crawl.

Blooping Tape. A small opaque tape used to silence undesired portions of sound tracks, generally caused due to a passage of the splice through a sound reproducer. The process is referred to as Blooping.

Blow-Down. The opposite of a blow-up. See Blow-up.

Blowout. The term blowout is used to refer to the complete loss of highlight detail in an image, generally caused due to overexposure.

Blow-Up. The process of enlarging a film frame to a larger gauge (i.e. 16mm to 35mm or 35mm to 70mm).

Blue Screen Compositing. The process of making all blue elements in an image transparent and placing a different background underneath.

Blue-screen, Green-Screen. A blue or green colored screen cloth used to separate a subject from its background and later replacing it in post-production with a different background. See Green Screen Composition.

Blurb. Another name for a sponsored commercial spot or advertisement.

Bobbinet. A cloth used for grip scrims and for darkening windows.

Body Double, Double. A person hired to take the place of an actor in scenes that require an aesthetic close-up, generally of a body-part; oftentimes used in nude scenes. A body double is not to be confused with Stunt Double or Stand-In.

Body Makeup. Makeup applied to the talent's body.

Bokeh. A term referring to the way in which a lens renders a points of light that's out of focus.

Bomb, Box Office Bomb. A financial disaster that fails to cover its cost in the box-office. *(e.g. '47 Ronin', 'Mars Needs Moms', 'RIPD', 'John Carter', etc.)*

Boom Microphone, Boom, Boom Mic. A long pole (fishpole) with a microphone attached to its end. Used by the Boom Operator to capture sound and dialog.

Boom Operator. An assistant to the Production Sound Mixer who is responsible for the operation of the boom microphone and keeping it out of frame.

Boom. A telescoping counter-balanced pole for camera or microphone.

Bootleg. A term used to refer to any illegally pirated, unauthorized version of a film.

Bottom Chop. A flag used to block light from illuminating the floor or the bottom part of a scene.

Bounce-Board. A white or silver foam card used to reflect soft, indirect light on a subject by bouncing light off the card.

Bowdlerized. A term referring to "cleaning-up" disturbing, vulgar, or adult content in order to make a film appropriate for mass market consumption by a younger audience.

Box Rental. An additional fee paid to a crew member who brings and uses their own equipment on set.

Box-Office. A term used to describe the commercial success or failure of a theatrically released film. The higher the box office, the bigger the revenue.

Bracketing. The method of shooting the same sequence several times with different camera settings to try and reach a certain desired effect.

Branch Holder. A pipe-like unit used to hold branches, wooden poles, or other items.

Breakdown Artist, Costume Design . An artist specializing in "breaking down" garments. *(Making new clothes appear dirty, faded and worn.)*

Breakdown Script. A pre-production process in which each scene is isolated, planned and itemized by cast, crew, props, equipment, etc.

Breast Line. A guide-line attached to items being hauled up on a crane or by a pulley.

Bridging Shot. A shot or effect which indicates the passage of time.

Broad. A light used for general fill.

Brute. A brute arc light, typically 225 amps DC powered.

Building a Scene. The editing process of setting a scene up for a climax.

Bulk Eraser. A demagnetizer used to erase sound from a film roll.

Bullet Time, Time Morphing. A visual effect that enhances a slow-motion shot by allowing the camera to move around the scene at a normal speed while action is slowed-down significantly. The term was trademarked by Warner Brothers following the release of The Matrix.

Bumper. The segment running before the start of a film that contains studio trademarks and logos.

Burn Out. The process of increasing gain levels and deliberately whitening out highlights.

Burn-in Time-Code. The process of superimposing a timecode over part of the picture.

Bus. An auxiliary audio track used for grouping two or more tracks together for processing.

Butt Splice. A splice made by joining two pieces of motion picture film together when the ends do not overlap.

Buyer. A crew-member who works with, and reports to, the Set Decorator.

Buzz track. An audio track capturing the ambient noise of each location.

Buzz. Another word for hype.

C Stand. A grip stand.

C.47. A clothespin used to secure gels to barn-doors.

Cable Sync. An outdated method of synchronizing sound. *(Popular during the time of the talkies.)*

California Scrim Set. A lighting scrim set.

Call Sheet. A sheet of paper issued to the cast and crew to inform them of when and where they should report for each day of filming.

Cameo. A small role or appearance in a movie performed by a well-known actor.

Camera Angle. The view-point chosen from which to shoot the scene. See Angle.

Camera Assist. See Focus Puller.

Camera Blocking. The process of pre-planning and rehearsing the placement and motion of the camera and focus within in a scene.

Camera Crew. Individuals responsible for the operation of the cameras. *(Job titles include the Camera Operator, Camera Assist, DP, Focus Puller, Dolly Grip, etc.)*

Camera Dolly. A specialized dolly installed on a track for the purpose of producing smooth, tracking camera motion. Dolly shots can be created with a dolly or emulated using a variety of indie equipment.

Camera Loader, Clapper-Loader. The person in charge of operating the clapper and loading film stock into magazines.

Camera Log, Camera Report. A written detailed form used to log shots and takes in each roll or memory card.

Camera Noise. The noise emitted by the camera. Not to be confused with Picture Noise.

Camera Operator. The crew member responsible for operating the camera.

Camera Stock. Another word for film.

Camera Tape. A white cloth tape used for many purposes on-set, mainly for labeling magazines.

Camera Wedges. Small, 4-inch wooden wedges.

Camera. A device fundamental for capturing still and moving images. The most common cameras used in movies today are film cameras and digital cameras.

Can, "In the Can". A term used to suggest that all the shots have been completed and a film is ready for post production.

Candela. A unit of light intensity equivalent to a standard candle.

Candlelight. Warm lighting provided by candle-light or a small fire.

Canted Frame. Also known as 'Dutch Angle', a Canted Frame is an angled camera frame that is not parallel to the horizon.

Caption. A descriptive line of text appearing at the bottom of the screen.

Card Reader/Writer. A digital device which transfers data from a camera's memory card to a computer without the need for a direct connection to the computer.

Cartoon. An animated TV show or motion picture.

Cash Cow. A film that produces proportionally higher income or profit over a prolong period of time.

Cash Flow. Another word for net-profit.

Cast. A term used to refer to the actors, performers and talent appearing on film.

Casting Call: See Auditions.

Casting Couch. The shady practice when unknown young actors or actresses are offered to exchange sexual favors (literally on an office couch) with a casting director or producer in order to land a role in a film.

Casting Director. The Casting Director is the person responsible for presenting potential actor picks to the director.

Casting Society of America, CSA. The Casting Society of America is a professional organization of Casting Directors working in theatre, film, and television.

Casting. The process of auditioning, selecting and hiring actors to play characters.

Caterer. A person or company providing food for the cast and crew during the production.

Catharsis. The release of emotional tension and feelings of relief after an event in the film had reached its climax.

Cautionary Tale. Referring to a narrative with an important moral message.

CC Filters, Color Compensating Filters. Filters used to fine-tune and control the color balance influenced by light.

Cel. A term used to refer to a single animation frame.

Celo. A form of wire-mesh cookie coated with plastic. See Cookie.

Cement Splice. A negative-cutting splice.

Censorship. The process of deciding what portions of the film need to be cut based on their content. Some films are censored all together. See Banned Films.

Century Stand, C-Stand. A multipurpose grip stand.

CGI, Computer Generated Imagery. The process of animating visual elements digitally and incorporating them into a shot or scene to produce an illusion that they are part of the scene.

Chain Of Title. A way of verifying proprietary copyright ownership in a film.

Chain Vise Grip. A clamp vise grip with a chain.

Chammy. A soft, round pad that wraps around the viewfinder cup.

Change Pages. Changes to the script made during production.

Changeover Cue. A small dot mark at the end of a release print reel (at the right-top corner of the frame) that signals to the projectionist the moment at which to switch over to the next reel.

Changing Bag. A black bag used for loading film into magazines.

Channel. Channels are individual image components, when mixed, they produce a color image.

Character Actor. An actor who specializes in playing well-defined, unique or eccentric characters.

Character study. A film in which the definition of the main character's personality is more important than the plot or narrative.

Character. A person in a story, performed by an actor.

Cheater Cut. The Introductory footage put into the beginning of a serial episode to present the events that took place in the previous episode.

Check Print. A print made for the purpose of verifying the look and quality of an effect.

Checkerboard Cutting. A way of removing the visual image of the film splice.

Chemistry. Referring to how well two actors work together and complement each other on-screen.

Chiaroscuro. The art of using strong contrast between shadows and highlights to produce a cinematic composition.

Chick Flick. Films that appeals mainly to women. *(e.g. The Notebook {2004}, Clueless {1995}, Mean Girls {2004}, When Harry Met Sally {1989}, etc.)*

Child Actor. Any actor under the age of 18.

Chopsocky. Slang for a martial arts film

Choreographer. A choreography artist who plans and designs artistic physical movement in film such as fighting and dancing.

Choreography. The art of designing specific movement sequences.

Chroma key. A process of digital compositing in which a specific color in an image is made transparent. Commonly used to remove green screen / blue screen backgrounds. See *Green Screen Composition*.

Chrominance. (1) Color information element in a digital video signal. (2) The color property of light.

Chyron. Another name for Lower Third. See Lower Third.

Cinch Marks. Film scratches and marks caused by winding.

Cinema Audio Society, CAS. A non-profit organization formed in 1964 for the purpose of sharing information with sound professionals in the motion picture and television industry.

Cinema Verité. A realistic documentary-like filmmaking style pioneered by Jean Rouch. *(The Act of Killing {2012}, West 47th Street {2003}, Project X {2012}, Down for Life {2009}, etc.)*

Cinemascope. An anamorphic system used for filming and projecting widescreen films in the 1950s.

Cinematic. A moment, scene, or shot in a film that represents the "essence" of cinema, oftentimes a visually appealing shot or an emotional moment in a scene.

Cinematographer, DP, Director of Photography. An artist responsible for capturing images on film or digitally through the artistic and technical use of cameras and lights. Understanding the qualities of lights, shadows, and color is an imperative trait in a good cinematographer.

Cinematography. The combination of art and science of motion picture photography.

Cinephile. A film enthusiast or devotee.

Cinerama. The process of projecting a film from three 35mm projectors to produce one huge widescreen, used as a cinematic attraction in the 1950s.

Cinex Strip. The process of testing and printing frames at different exposure level.

Clamp Light. An adjustable lighting fixture.

Clapboard, Clapper, Slate. A board used to assist in the synchronization of picture and sound while marking scenes, shots and takes.

Classification and Ratings Administration, CARA. The division of the MPAA responsible for administering certificates.

Claymation. The process of animating clay characters.

Clean Speech. A perfect take in which the dialogue was performed without an error.

Click Track. A series of audio cues on a prerecorded track used to ensure proper timing and music sync.

Cliffhanger. An intense, dramatic moment with no conclusion. Named for the practice of leaving the main character hanging from the edge of a cliff.

Climax. The peak of anxiety or emotional tension in a film.

Clip. A short piece of video or audio.

Clipped Whites. The loss of detail resulting from a peak or limit of an electronic signal.

Closed caption, CC. Also known as subtitles. A textual representation of the dialog and actions in a film to service the hearing impaired or to translate a foreign language.

Close-up, CU, Tight Shot. A shot which tightly frames a person or an object from top to bottom.

CMOS. The main imaging technology used in DSLRs today.

C-Mount. A screw mount lens used primarily on 16mm cameras.

Coaxial Cable. A sturdy copper cable used for video signal transmissions. Not to be confused with Shielded Cable.

Co-Axial Magazine. A type of double-chamber magazine.

Codec. An application used to encode or decode video for playback and recording. *(Popular formats include H.264, MPEG, AVCHD and PRORES, among others.)*

Coded Edge Numbers. A system of time-coding printed films.

Collection Agreement. An agreement made between the producer, the financing company, and the collection agent *(e.g. The National Film Trustee Company Limited)*. The role of the collection agent is to collect and distribute the proceeds of a film among the participants.

Color Balance. The adjustment of color casts from an image, camera or monitor.

Color Bars, SMPTE Color Bars. A test pattern used to sync the color and brightness settings of a projector with those of the footage.

Color Calibration, Monitor Calibration. A process of calibrating the image source and the monitor to use a similar color standard.

Color Cast. A dominating single color in an image, typically unwanted cast by an environmental light source.

Color Consultant. A technical advisor providing advice for cinematographers.

Color Correction, Color Timing. The process of adjusting and repairing flaws in color balance and contrast to make the image appear more aesthetically accurate. This process is generally followed by a Color Grade. See Color Grading.

Color Depth, Bit Depth. The number of bits used to define the color of a single pixel.

Color Enhancement. A post-production modification made to an image by a colorist to reflect a mood, atmosphere or meaning.

Color Grading. The process of altering or enhancing the overall visual feel of a shot or scene by adjusting the color of an image to produce a desired effect or make the picture more visually pleasing. Most often, color grading is used to help set a mood or reflect a specific environment.

Color Space. A mathematical model of color and how it mixes together to produce a neutral, white color.

Color Temperature. The temperature of a light source. A lower value means colder (blue) while a higher value means warmer (red).

Color Timing. See color grading.

Colorimeter. A device used to analyze the characteristics and calibration of color.

Colorist, Color Timer. A color correction and grading artist who uses digital tools to manipulate the image and improve the aesthetics and quality of a film. See Color Grading.

Colorization. The process of hand coloring frames in post-production.

Combo Stand. A heavy-duty 2K stand.

Comic Relief. The use of a humorous character or situation in an otherwise serious or tense scene. *(Leo Getz - Lethal Weapon, Ruby Rhod - The Fifth Element, Pintel and Ragetti - Pirates of the Caribbean)*

Coming-of-Age. A genre of films focusing on the psychological transformation and personal growth of a character or group of characters from youth to adulthood. *(The Breakfast Club {1985}, The Perks of Being a Wallflower {2012}, Juno {2007}, etc.)*

Command Performance. A dominating performance in a film by an actor.

Commentary. A description of a scene or an event by a commentator, often via voice-over.

Compact Flash Card (CF card). A commonly used mass storage flash card. Not to be confused with SD Cards or SDHC cards.

Compander. A noise-reduction system designed to improve audio signal.

Compilation . A film or sequence edited together from previously released or archive footage in a new sequence.

Completion Bond, Completion Guarantee. A form of insurance offered by a guarantor (generally to a distributor or a financier) which assures the completion and delivery of a feature film by a given date. It is used to protect the distributor who often requests a completion bond before paying an advance if the film has yet to be completed. These bonds are issued by Completion Guarantors (Filmfinances.com).

Complication. A plot event that complicates a film or a scene.

Component Signal. A high-bandwidth analog video signal.

Composer. A musician responsible for writing and producing the musical score of a film.

Composite Print. A film print including picture and sound on the same strip.

Compositing. The post-production process of digitally combining different visual elements into a sequence or blending 3D animated clips with real-shot footage. Generally, this is done to produce shots that cannot be filmed in real life or would otherwise be too impractical to create. A sub-category of Visual Effects.

Compositor. A visual effects artist who handles composition.

Compression. A method of reducing the size of a digital image file to clear up storage capacity in memory cards and hard drives.

Concept Art. An illustration created by an artist (i.e. concept artist) to convey a certain style or look of a film, scene, or character during pre-production. For large-scale productions, concept artists will work while filming it still in progress.

Condenser. A type of microphone.

Conductor, Musical Conductor. A person in-charge of directing the orchestra's performance during a recording session.

Construction Coordinator, Foreman, Construction Manager. A person in charge of overseeing set-construction.

Contingency. A predefined amount of money added to the budget to cover potential cost overruns, generally 10% of the budgeted cost of production.

Continuity Report. A report which tracks the progress of everything that happens in a scene for the purpose of ensuring continuity.

Continuity. The process of maintaining consistency of action or events in a scene or sequence.

Continuous. A term used to define action as it moves through locations, scenes or shots without interruptions.

Contract player. Any actor under contract.

Contractor. Any independent person on-set who is not represented by a union or guild and offers a paid service to the production as opposed to a paid employee. *(Can be a part of the production crew, camera crew, VFX crew, catering crew, makeup, or publicity departments)* Contractors are often contracted by the production, a department head, or the studio.

Contrast, Gamma. The visual difference in luminance and color shading that makes an object distinguishable, or "pop-out." In film, the change in contrast is produced by altering the gamma and changing the difference between the lightest and darkest elements of the image.

Control Track. An embedded pulse-track found in standard videotapes that allows a recorder to sync and define its recording speed (LP, SP, etc.).

Coogan's Law, The California Child Actor's Bill. A law designed to protect the earnings of child-actors for when they enter adulthood.

Cookie. A flat board with irregular holes, placed in front of a light for the purpose of producing unique shadow patterns on an object, subject or backdrop.

Cooperative Advertising. The advertising cost shared between a distributor and exhibitor.

Co-Producer. A producer responsible for various managerial producing functions.

Coproduction Treaty. An opportunity offered by two nations to film production companies for the purpose of promoting international co-productions. Local filmmakers can work with foreign producers or post-production facilities and enjoy local tax breaks, benefits, and other incentives from both countries.

Copy. Term used to mean "understood"

Copyright Clearance Center. An organization offering licensing services for copyrighted materials.

Copyright Search. An online or offline search in the US Copyright Office to check on the status of a film's copyright and check for interest in the work by third parties.

Copyright. A legal protection over intellectual property. Used to define ownership of a feature film by submitting it to the U.S. Copyright Office.

Core. A plastic cylinder hub used to hold film for transport or storage.

Costume Buyer. A person responsible for buying fabrics and garments.

Costume Design. A department responsible for designing and creating costumes for characters, performers and extras. Typically used on period or fantasy films.

Costume Designer. The person in charge of designing the clothing and costumes worn by the cast.

Costume Standby. A person responsible for costume continuity and assisting the cast with costumes. They are generally present during the shoot and manage the costume staff.

Costume Supervisor. The person in charge of preparing and reproducing costumes created by the designer. They hire staff, maintain the budget, and handle logistics in addition to consulting with the designer to ensure that the designs are being properly executed.

Counter. A device used to measure the length of film.

Courtroom Drama. A legal film genre, often-times taking place in a courtroom. *(A Few Good Men {1992}, Runaway Jury {2003}, The Accused {1988}, etc.)*

Cover Set. A "backup location", most commonly an outdoor location reserved for use in case the intended location cannot be used.

Coverage. The additional footage and camera angles captured during filming that are made available to the editor during post-production. More coverage equals more shot choices in post-production.

CP Filters. Color printing filters.

Craft Service. A single person or a group of people responsible for providing food and beverages on-set. (Not to be confused with Prop-Food).

Crafty. A craft services person.

Crane Shot. A high shot taken by a camera on a crane, jib or boom.

Creative Consultant. An ambiguous, non-official credit given to a person who assisted with the creative process in some way.

Creator. The primary creative force behind a film, oftentimes it's the person who incepted the film.

Credits. A list of individuals and corporations who contributed and/or are responsible for the making of a film.

Crew, Crew-members. The individuals involved in the technical production of a film.

CRI. Color Reversal Intermediate. A duplicate color negative.

Cribbing. Short lumber pieces used for various grip purposes.

Crisis. The peak of emotional tension in a film leading to a climax or a conclusion.

Critic. A person who's in the business of publishing movie reviews from either an artistic or entertainment point of view.

Cross Dissolve. A transition fading from one clip to the other.

Cross-Conversion. The process of changing NTSC to PAL (and vise verse) to comply with TV standards.

Cross-Cutting. Cutting back and forth between scenes to establish simultaneous action.

Crossfade. A gradual mix transition between two audio clips.

Crossing. A call to alert the camera operator before walking pass the lens.

Crossover Film. A film produced for a specific niche market which could easily appeal to another, unrelated audience.

Crossover, Audio. Also known as a 2-way crossover. Crossovers are a class of electronic filters used in audio applications.

Crosstalk. In stereo, crosstalk is the phenomenon where an undesired signal in one audio channel will affect the another channel.

Crowd Shot. A wide shot of a large group of people (often extras or CGI). See Massive.

Crushed Blacks. Refers to the intentional loss of detail in shadows (blacks) by under-exposing the image or increasing the contrast in post production.

CU, Close-up. Filling the frame with an object or person.

Cucoloris. Another word for a cookie. See Cookie.

Cue Cards. A method of printing and running dialog to help an actor remember their lines. *(Done vis cards, teleprompter, or iPads.)*

Cue Sheet. A list of copyrighted music used in a film, which is a crucial part of the deliverables requested by the producer or distributor.

Cue. A signal used to mark the start of the actor's performance.

Cult Film. A film that has acquired a cult following. *(2001: A Space Odyssey {1968}, A Clockwork Orange {1971}, Office Space {1999}, Mean Girls {2004}, etc.)*

Cup Blocks. Wooden blocks used to keep light stand wheels from moving.

Cut, Cutting. (1) To switch from one shot to another. (2) A call made by a director at the end of every take to inform the camera operator to stop recording. (3) The process of selecting and assembling various shots to produce a sequence.

Cutaway Shot. Cutting to a single shot of something that interrupts the flow of action in the scene.

Cutter, Fitter, Tailor. A Costume Technician responsible for on-set fitting. They work with the cast.

Cyc Lights. Row lights used to evenly illuminate a background.

Cyclorama. A panoramic, 360 degree platform that provides the illusion of a seamless, colored backdrop, generally found on studio sets.

D1. Uncompressed SD format developed by Sony.

D2. Lower cost alternative to D1, developed by Ampex.

D3. Lossless format developed by Panasonic.

D5. A tape format developed by Panasonic.

Dailies, Rushes. Raw print or digital footage ready for immediate view by the director.

Dark Current, Picture Noise. A pixilated image noise created by the absence of light.

Dark Horse. When an unknown film becomes nominated for a major award.

DAT, Digital Audio Tape. A tape-based digital audio recording medium used in field recording.

DAW, Digital Audio Workstation. A hardware/software system used for recording, editing and playing digital audio.

Day Out of Days. A list of paid working days for cast and crew.

Day Player. A title given to a crew member hired to work for just one day.

Day-for-Night Shot. Filming a day scene with the intention of making it look as if it was shot at night. The effect is later perfected in post production.

Daylight Spool. An aluminum spool used to protect film stock during a daylight camera load by keeping it from becoming exposed.

dB, Decibel. A unit of measurement for the intensity of a sound wave.

DCP, Digital Cinema Package. A series of files required for digital cinema projection.

Dead Sync. When sound and picture are perfectly synced.

Deal Memo. A contract defining the terms of employment, salary, conditions, and other essentials for crew members.

Decode. The process of reading and outputting encoded data.

Decoupage. A French term referring to the art of "film design" (i.e. look and feel).

Deep Focus. A cinematography technique of using a wide-angle lens with small apertures to produce a large depth of field and keep the image sharp and clear, it keep everything in focus.

Deferee. A person to whom a deferment is paid.

Deferment. Money payable to an artist under contract. See Remittance Advise.

Deliverables: A list of items required by a distributor or festival to prepare a film for screening, release, marketing and distribution.

Denouement. A concluding scene in a film following the story's climax.

Density. The volumetric mass of light or color.

Depth of Field, DOF. The measure of space between the nearest and furthest objects in a scene and the amount of space within the lens view which will remain in focus.

Designer. Any artist responsible for designing materials, art and concepts in the film.

Design. The "look" of the film.

Deuce. A 2K fresnel lighting unit.

Developing. The process of converting unexposed film into a visible image.

Development. The first step in pre-production. The development process includes a script, character development, look development, etc.

DGA, Director's Guild of America. A labor union representing directors, assistant directors and production managers, among others.

Dialect Coach. A person in charge of training cast-members in diction and the use of accents or language to fit the character they're playing.

Dialogue Editor. A sound editor responsible for assembling, synchronizing and editing dialogue.

Dialogue Track. A separated audio track consisting only of film's dialog.

Diegetic Sound. Sound effects emitted by on-screen action. It is a part of the narrative sphere of the film

Difference Key, Difference Matte Key. A method of separating a subject from its background by extracting matte information in post production.

Diffusion. The process of using a diffuser or translucent sheet to soften harsh lights.

Digital Asset Management, DAM. The process of managing the way film and digital assets are handled during production.

Digital Compositor. A visual effects person responsible for digital compositing. See Compositing.

Digital Imaging Technician. A digital cinematographer responsible for digital quality control.

Digital Intermediate. The process of digitizing a film, color correcting it and re-outputting it to film before it is ready for theatrical distribution.

Digital Negative, DNG. An open raw image format created by Adobe.

Digital Production. Any production that uses digital cameras, as oppose to film cameras.

Digital Recording. The method of encoding and recording analog signals as binary information.

Digital Theatre Systems, DTS. A series of surround sound audio technologies.

Digital Zoom. The in-camera process of image cropping to produce a zoom effect.

Digitize. The process of preparing analog video for a digital edit by converting it to a digital format.

Dimmer. A device for controlling light intensity.

Diopter. An adjustable portion of the viewfinding system.

Direct sound. The method of recording audio simultaneously with the image, as opposed to using two separate mediums. See Double-System Sound.

Directing the eye. Using the camera, light and frame to draw the audience's eye to something important on-screen.

Directional Characteristic. The variation of sound based on the microphone's position and angle.

Director of Photography. Another term for Cinematographer. See Cinematographer.

Director. The principal creative artist driving the vision of the film and responsible for its execution.

Director's Cut, Final Cut. (1) A contractual clause giving a director final say on how the ultimate film will be edited. (2) The final cut presented by a director to the studio.

Dirt. A sand bag.

Discovery Shot. In a scene, a discovery shot occurs when the camera moves or pans to unexpectedly find or discover a person or object previously undisclosed to the viewer. *(Used often on It's Always Sunny in Philadelphia.)*

Dissolve. A fading transition between two shots.

Distortion. An intentional or unintentional modification made to the original signal.

Distribution Agreement. An agreement granting a distributor the rights to exploit and sell the film.

Distributor. The company responsible for organizing and coordinating the marketing, exhibition and distribution of a finished film to its intended audience.

Ditty Bag. A tool-bag used to store camera and lens essentials.

Divinci Resolve. Color correction and grading software by Blackmagic Design.

DME, Dialogue, Music and Effects. The film's final audio mix without the dialogue. Used for foreign language dubbing. See Dubbing.

Documentary. A non-fictional, educational film. *(The Act of Killing {2013}, Searching for Sugar Man {2012}, Food, Inc. {2009}, etc.)*

Dogme 95. A filmmaking movement started in 1995 by Lars von Trier and Thomas Vinterberg.

Dolby 5.1. A six channel digital surround sound system by Dolby. *(Includes five speakers and one sub-woofer for bass)*

Dolby Stereo. A digital audio encoding system by Dolby.

Dolly, Dolly Shot. A smooth motion or tracking shot in which the camera is mounted on a dolly.

Dolly Grip. A grip crew member responsible for operating dollies and cranes.

Dolly Tracks. A set of tracks upon which a dolly can be mounted.

Domestic Rights. The rights to distribute a film in a local region (I.e. North America).

Doorway Dolly. A dolly narrow enough to fit through a doorway.

Dope Sheet. A detailed list of every scene and shot information.

Dots. Small flags used to manipulate light.

Double Bill. Two movies shown one after the other, often at a discounted admission price. The first film being the major attraction, the second film is referred to as a B Movie.

Double Exposure. The process of exposing a single frame twice to produce a ghostly effect.

Double Take. A surprised second look at an object or person.

Double, Stunt-Double. A person performing difficult or dangerous stunts. Not to be confused with a body-double.

Double-System Sound. The method of recording sound and picture on separate devices and synchronizing them later in post production.

Down-conversion. The process of converting HD to SD.

DPX, Digital Picture Exchange. A high-end file sequence format for use in digital intermediate and visual effects.

Draftsman. One who creates set construction plans.

Dresser. An on-set wardrobe assistant helping actors with their costumes.

Drive-in. An outdoors cinema structure where viewers can watch films from the privacy of their cars.

Driver. A crew-member in charge of driving equipment between sets and locations.

Drop Frame. A form of time code in which two frames are dropped every minute.

Dropout. A sudden loss of signal resulting in the loss of data or excess noise.

DSLR, Digital Single Lens Reflex. A single lens reflex camera that captures digital images and video.

Dub Stage, Mix Stage. The final sound-mix room.

Dub. To add a new, dubbed dialogue track on top of the film's M&E track. Used when selling the film overseas in cases where subtitles are substituted for a voice dub.

Dubber. A magnetic playback unit with exceptional sound reproduction quality. Often used in IMAX Sound Systems.

Dubbing. The process of syncing an actor's voice with lip movements during ADR.

Dumb Side. Looking at the direction of the camera or lens, instead of right at it.

Dunning. The method of combining and matching studio lot shots with footage shot on location.

Dupe. A copy of a negative. Short for duplicate.

Dutch Tilt, Dutch Angle, Canting. A shot in which the camera is tilted diagonally at a canted angle.

Duvetyne. A heavy black cloth used for blocking light, blacking out windows, hiding cables and other uses.

DV. A Standard Definition (SD) data format with a resolution of 640x480 / 720x480.

DVD. An optical disc format.

Dynamic Frame. The process of fitting a frame into the appropriate ratio used in a scene.

Dynamic Range, Image. The difference between the brightest and darkest portions of an image.

Dynamic Range, Sound. The decibel difference between the loudest and quietest portions of a sound.

Dynamic. A gradual change.

Dystopia. A place or state in which the conditions of life are unpleasant, bad or terrifying.

Ear, Sider. Blocking the light with a flag.

Easter Egg. An event, object or character in a film too subtle to be noticed.

Echo. The reflection of sound waves from a surface.

Edge Numbers. Numbers printed along the edges of a strip of film. Allowing the negative cutter to keep track and identify frames.

Edge Track. The standard position for audio placement on magnetic film.

Edit Decision List, EDL. SMPTE cut-list created by an offline editing system and used during post production. The list is composed of the order in which the editor had created the cut sequence.

Edit Master. The tape containing the final cut.

Edit Points. The beginning and end points of an edit.

Editing. The art, technique, and practice of selecting and assembling raw shots and combining them into a coherent sequence.

Editor. A person who handles editing.

Effective Output Level. The microphone sensitivity rating defined as the ratio in dB of the power available relative to sound pressure. *

* Source: Wikipedia

Effects Animation. The control over particle elements such as explosions, smoke, fire, smoke, rain, etc.

Effects Stock. High-quality 35mm film stock optimized for shooting visual effects. See Vistavision.

Electrical Department. The department responsible for all light and electrical wiring on set.

Electrician. A grip responsible for assisting the lighting crew and handling the distribution of electricity on-set.

Electronic Viewfinder, EVF. A digital viewfinder. See Viewfinder.

Ellipsis. A plot device used to keep important sections of the narrative hidden from the audience.

ELS, Extreme Long Shot. See Long Shot.

Emulsion. The most fundamental film layer on which the image is formed.

Encode. The process of writing video information onto a new file, generally for compression or to meet deliverable requirements by a distributor or exhibitor.

End Credits, Closing Credits, Rear-Title Crawl. Movie credits rolling at the end of a film. See Credits.

Ensemble. A large production of well known or celebrated actors in which the main actors are assigned an equal amounts of importance and screen time.

Envelope. The way amplitude is plotted against time.

Environmental Sound. Low-volume audio coming from on-screen action.

Epic. A big budget film, often produced on a massive scale with heavy visual effects, stunts and a large cast.

Epilogue. When a character reflects upon the conclusion of the story.

Epiphany. A moment of sudden spiritual insight.

Episode. A self-containing segments of a greater plot.

Equalization. The process of balancing sound frequency.

Errors & Omissions Insurance, E&0. Insurance purchased to protect the producer and distributor against claims arising out of copyright infringement.

Establishing Shot. A shot intended to establish a location and the time of day.

EVF. Electronic View Finder.

Exciter Lamp. An incandescent lamp used in film projectors to illuminate the optical sound track.

Executive Producer. A producer representing the film production company. Generally responsible for handling the business and legal aspects of the production.

Exhibitor. A movie theatre.

EXIF, Exchangeable Image File. A format used for storing metadata.

Experimental Film. A low budget artistic film representing the director's pure artistic vision without consideration for marketability or audience. Not to be confused with Arthouse Film. *(Man with a Movie Camera {1929}, Inland Empire {2006}, etc.)*

Exploitation Film. A low budget film attempting to exploit a genre or niche. Most often racial, sexual, violent or vulgar. *(I Spit on Your Grave {1978}, Faster Pussycat! Kill! Kill! {1965}, Vanishing Point {1971}, etc.)*

Export. The process of sending a file for print. The term is also used to describe the action of saving a video file from within the editing software.

Exposition. Background story necessary to the advancement of the storyline.

Exposure Compensation. The technique of adding to subtracting exposure levels to produce an either darker or lighter image. Exposure Compensation is also an in-camera feature that can automatically adjust calculated exposure levels.

Exposure Index. A way of measuring how light-sensitive a particular type of film or sensor is.

Exposure. The amount of light passing through the lens aperture and striking the surface of film or digital imaging sensor.

Expressionism. The distortion or exaggeration of visual elements to reflect inner feelings and emotions of a characters or filmmaker.

Extension Tubes. A hollow metal lens-mount tube used to turn a regular long lens into a macro lens for ultra-close shooting.

Exterior, EXT. In screenplays, EXT is used to indicate a scene taking place outdoors.

Extra. A person appearing on-screen who is not a member of the cast and does not have any lines. Can be a Background Extra (used in the background) or a Featured Extra (used in a tight shot, visible on-screen).

Extreme Close-up, ECU. A very tight, detailed shot in which the subject is much larger than the frame.

Eyeline Match. A cut that establishes the subject at-which the character is looking at.

Fade. A measured, gradual transition from one shot to another.

Fake Shemp. Another name for stand-in. A person appearing on film as a replacement for another actor.

Farce. An exaggerated or improbable comedy. *(The Hangover {2009}, The Pink Panther {2006}, Oscar {1991}, etc.)*

Fast Motion. A shot in which time appears to move faster than normal.

Fay. A form of Parabolic Aluminized Reflector Lamp.

Feather. A technique used for blurring the edges of a frame or mask.

Feather Light. The process of softening shadows by moving a flag closer to or further away from a light source. See Flag.

Feature Film. A movie at least 40 minutes long.

Feature Presentation, Main Attraction. The main or advertised screened film.

Featured Background. The performers placed in the background of a major action in a scene.

Featurette. Another term for short film under 40 minutes.

Feed Lines. Lines of dialogue read outside the camera's range.

Feel Good Film. A light-hearted film that ends with an audience-pleasing conclusion. *(Anchorman {2004}, The Fantastic Mr. Fox {2009}, Breakfast at Tiffany's {1961}, Safety Not Guaranteed {2012}, etc.)*

Femme Fatale. A seductive and dangerous female character in a movie. *(Kathryn Merteuil in 'Cruel Intentions', Selina Kyle in 'The Dark Knight Rises', Lola-Lola in 'The Blue Angel', Jennifer Check in ' Jennifer's Body ', etc.)*

Festival. An event at which films can premiere and win awards. *(Cannes, Sundance, etc.)*

Field Monitor. An large-screen alternative to the on-camera LCD screen.

Fifteen minutes. A short-lived celebrity.

File Format. The way in which a file is saved. (MOV, AVI, MP4, etc.)

Film Aesthetics. The study of film as a visual art form.

Film Artifact. Unwanted film damage or defects.

Film Base. A transparent substrate which acts as support for the photographic emulsions and magnetic coatings.

Film Buyer. Buyers are responsible for purchasing films on behalf of the organization they represent. *(Movie studios ,film distributors, production companies, theaters or TV networks.)*

Film Cement. A common term for the welding solvent used to melt and fuse two pieces of film together.

Film Clip. A short shot segment captured by a camera (on film or digital).

Film Developing. The process of developing film stock and transferring the footage to a negative print.

Film Editor. See Editor.

Film Form. The sum of all the moving parts which make up a completed finished film.

Film Gauge. The width measurement of film strip. E.g. 35mm, 16mm, etc.

Film Grain. The random texture of processed film caused due to the presence of small particles on the film strip.

Film Loader, Clapper-Loader. A crew-member responsible for loading film magazines and managing film inventory. They also operate the clapper-board.

Film Magazines. A reel of film stock ready for use in a camera.

Film Noir. A genre of stylish crime dramas produced in the 1940's and 50's. Noir has a distinct, high-contrast visual style and is often presented in black and white. *(Double Indemnity {1944}, Out of the Past {1947}, The Third Man {1949}, Sunset Blvd. {1950}, etc.)*

Film Plane. The flat surface receiving light after it had passed through the lens. The point from where the distances on the focusing ring should be measured.

Film Printing. The process of transferring images from a negative print to a release print.

Film Review. A published review by a critic. See Critics.

Film Riot. A popular DIY filmmaking web series hosted by Ryan Connolly.

Film Stock. Ready-to-use film roll.

Film Within a Film. A plot device in-which the events surrounding a fictitious film is the film's subject. *(Tropic Thunder {2008}, Zack and Miri Make a Porno {2008}, Let's Make a Movie {2012}, etc.)*

Film. (1) A thin sheet of transparent material on the film negative used to create images via light exposure. (2) Motion Picture.

Filmmaker. A person responsible for the making of a film. The term can apply to directors, producers and editors.

Filmography. A list of films by one director or actor, or on one subject.

Filter. (1) Any glass or plastic sheet that can be inserted in the optical path to alter or affect the image in some way. (2) A software add-on used to reproduce a desired effect automatically. (3) Any material used to absorb light, color or sound.

Final Cut. (1) The last edited and polished version of a film. (2) See Director's Cut.

Fingers. Small flags used to control light. See Flag.

Firewire. A high-speed data transfer standard used for connecting camera and audio equipment to computers.

Firmware. In-camera programs and features.

First Assistant Camera, 1AC. Responsible for keeping the camera in focus. See Focus Puller.

First Assistant Director, AD, 1st AD. Responsible for assisting the film's director and production manager.

Fish-Eye. A distorted ultra wide-angle lens used to produce wide panoramic or hemispherical shots.

Fixed Focal Length Lens. See Prime Lens.

Fixing. The removal of unexposed silver halides from a film during processing.

Flag. Black cloth used to keep light out of a portion of the composition.

Flare. A lens artifact caused by sunlight.

Flash Frame. The method of inserting a single frame into a sequence for the intention of producing a sudden dramatic effect.

Flash-in-the-Pan. Overnight success or recognition. See Fifteen Minutes of Fame.

Flashback. A scene reflecting on the past memories of a character.

Flash-Forward. The opposite of flashback. The method of depicting a character's thoughts or imaginations projected to take place in the near or distant future.

Flat Profile. Low contrast, low sharpness DSLR picture profile.

Flat. A large studio space used for constructing sets.

Flatbed. A machine used to edit film for a motion picture.

Flex File. A digital file that establishes timecode relationships.

Flex-Fill. A round collapsible reflector. See Reflector.

Flick. Another word for movie.

Flicker. A random stroboscopic light-pulse alternation produced by an improperly captured or projected film. Can be reproduced by increasing the shutter speed under a faster frame-rate.

Float. Undesired image movements caused by a faulty camera or projector.

Flood. A large, powerful light used to illuminate a large section of the set.

Flop, Bomb, Box-Office Bomb. A poor box office performance. The term is used to describe a film that is far from covering its production cost.

Flop, Flips. The effect of reversing an image horizontally.

Flux. The measurement of the perceived power of a particular light source.

Flying In. Sending a person or an object to a set.

Foamcore. Lightweight material used to create reflectors, soft boxes, and other items.

Focal Length Magnifier, Magnification Factor, Crop Factor. The ratio of a digital camera's focal length dimensions compared to a 35mm format.

Focus Group, Test Screening. A sneak-preview screening of a film to a select group of unbiased individuals before its general release.

Focus Pull. The process of refocusing the lens during a shot to keep an object or subject in focus or manually change the camera's point of focus. This task is done by the Focus Puller.

Focus Ring. A ring on a lens which is manually or automatically rotated to reach the desired level of focus.

Focus. The degree of sharpness and clarity of an object, subject or background in an image.

Fog Level. The minimum density of the unexposed area of processed film.

Fog Machine, Smoke Machine. A device emitting a dense vapor that resembles fog or smoke.

Foley Artist, Foley Walker. An artist responsible for producing and recording sound effects for a film during the Foley process. See Foley.

Foley Editor, Foley Mixer. A sound editor in-charge of editing the sound effects produced by a Foley Artist.

Foley. A sound design process of fabricating, re-producing and recording character-related sound effects such as footsteps, clothes-noise, breathing, fighting, etc. See Sound Design.

Follow Focus. A plastic focus control mechanism attached to the focus ring.

Follow Shot, Tracking Shot. A dolly shot that follows or tracks a moving subject or object.

Follow-Up. Any cinematic work that follows a particular action, scene or sequence.

Foot Candle. A way of measuring light. One foot candle is the volume of light produced by a single candle, one foot away.

Footage. Any portion of a film or digital sequence presented as a video or film clip.

Forced Perspective, Depth Perception. Producing the optical illusion that an object is bigger or smaller than it really is.

Foreground. An object or subject closest to the camera, contrast to the background.

Foreign Film. Any motion picture produced in a foreign country with a predominantly foreign dialogue.

Foreign Rights. The rights granted to a distributor to market, sell and distribute the film in other nations.

Foreshadowing. The method of supplying hints within the film regarding the outcome of a plot or scene.

Format. The language in-which a video file is encoded, the term is also used to describe the film's aspect ratio.

Fourth Wall. The imaginary wall that keeps characters from recognizing or directly addressing their audience.

Frame Rate, Frames Per Second, FPS. The frequency at which individual frames (still images) are presented to produce the illusion of motion. Most feature film are shot and exhibited at 24pfs.

Frame. The individual image used in a sequence of frames or a strip of film.

Framing. The way a camera is positioned to compose a shot, and the way in which subjects and objects are presented within the boundaries of the frame.

Franchise. A series of independent films that share a common ingredient, continuing characters and themes. Most often surrounding a single hero or group of heroes, each film moves the main characters or the overall plot forward until a conclusion is reached. *(Lord of the Rings, Star Wars, Harry Potter, Pirates of the Caribbean, etc.)*

Freeze Frame. The repetition of a single frame over-time to stop the action and view a motionless image for a period of time.

French Flag. A flag used to shade the lens and prevent undesired flare.

Frequency Response. The measurement of output sensitivity in sound/video playback and recording systems.

Frequency. The number of times a signal vibrates every second, measured in Hertz (Hz).

Fresnel Lens. A stepped-convex lens consisting of many small pieces of glass that allow large apertures and short focal lengths.

Fringing, Chromatic aberration. A type of distortion appearing as color bleeding along boundaries that separate dark and bright parts of the image. A common issue with cheap lenses.

Front Projection. A process of filming actors and foreground objects in front of a pre-shot projection.

F-Stop. A term used to describe the lens aperture and measure how much light passes through the lens and onto the sensor. Not to be confused with T-Stop. See T-Stop.

Full-Coat. A film layer on which sound is recorded and from which it is reproduced.

Furnie Blanket. A furniture or sound blanket.

FX. Abbreviation for Special Effects.

G. An MPAA rating certificate indicating that a film is suitable for all ages.

Gaffer Tape, Gaff, Gaff Tape. A type of cloth tape used in film shoots. It is stronger and sturdier than regular duct tape and does not leave a sticky residue when removed.

Gaffer, Chief Lighting Technician. The chief lighting technician responsible for planning and managing lighting and electrical equipment.

Gain. An increase in signal amplification. Expressed in decibels (db).

Gamma. The level of contrast in an image as captured by a camera and corrected to compensate for properties of human vision.

Gamut. (1) The limited range of colors available in a device or file format. (2) The range of voltages allowed for a video signal.

Gang Synchronizer. A device used to synchronize film and audio tracks recorded on magnetic film.

Garbage Matte. A specific matte used to remove undesired chroma residue ignored by a green-screen or blue-screen key effect.

Gary Coleman. A small C-stand or short tripod.

Gate. A Rectangular aperture in the front of a film camera where the film is exposed to light.

Gauge. The width of a film format, measured in millimeters. (35mm, 16mm, etc.)

Gel. A tinted sheet placed over a light source to change its color.

Gender Twist, Gender-Bending. When a character is played by an actor of the opposite sex. *(Julie Andrews in 'Victor Victoria' {1982}, Lee Pace in 'Soldier's Girl' {2003}, Dustin Hoffman in 'Tootsie' {1982}, etc.)*

General Release. The release of a film to the public via theaters, DVD, subscription, on-demand, etc.

Generator. An engine which generates electricity when shooting on-location or in a place where sufficient electricity is not available.

Genlock. A common method of syncing devices with a camera's video output.

Genre. The separation of films based on their theme, setting and topics. *(Drama, comedy, horror, fantasy, crime, etc.)*

Gigabyte (GB). A unit for measuring a computer's memory capacity. 1GB is the equivalent of 1,000MB (Megabytes).

Giraffe. A stand and boom-pole in one.

Go for. A radio call for a specific person on set. *("Go for Charlie")*

Gobo, Goes Before Optics. Any template used to produce light patterns and control the shape of emitted light.

Gobo Head, Gobo Arm. An adjustable clamp mounted at the top of a C-Stand.

Grading. The process of altering or enhancing the overall look of a shot or scene by adjusting its colors, saturation, contrast, etc. Color grading is used to help set a mood or a feel by manipulating colors. See Color Grading.

Graphic Artist. An artist responsible for the design of graphic elements appearing on-screen and created specifically for the film and the world in-which the story takes place.

Green Screen Compositing. The post production process of removing green or blue elements from a shot and replacing them with another image. This is a common method used to replace backgrounds.

Green Screen. A green cloth used for Green Screen Composition.

Greenlight. Meaning that a film is approved for production by the studio.

Greensman. A member of the crew responsible for arranging and maintaining landscape vegetation on set.

Grifflon, Griff. A durable surface used to reflect bounce light.

Grindhouse. A movie theater specializing in screening violent, exploitative, or racy low budget films. Grindhouse films are films produced specifically for such theaters. *(Coffy {1973}, Master of the Flying Guillotine {1977}, The Texas Chainsaw Massacre {1974}, Rolling Thunder {1977}, Grindhouse {2007}, etc.)*

Grip Tape. Another name for Gaffer Tape.

Grip. A skilled lighting and rigging technician responsible for maintaining and operating production equipment on set. (*Tripods, dollies, tracks, cranes, etc.*)

Gross Participation. A legal agreement promising to pay a portion of a film's net proceeds to a cast member or director.

Gross. The total sum of box-office revenue generated by the film.

Ground Glass. A flat surface in the viewfinder that is the same distance from the lens as the film plane. See Film Plane.

Guerilla Film. A very low-budget film, often shot without permission with a very minimal, often unpaid cast and crew. (*She's Gotta Have It {1986}, Paranormal Activity {2009}, Following {1998}, The Blair Witch Project {1999}, etc.*)

Guillotine Splicer. A film splicer.

Guilty Pleasure Film. A film enjoyed by an individual regardless of its public image or negative reviews. Often cheesy or badly acted films. (*Garbage Pail Kids Movie {1987}, Road House {1989}, Tango and Cash {1989}, etc.*)

Hair Stylists. Responsible for styling and maintaining the hair of anyone appearing on screen, including extras.

Handheld Shot. A shooting style in which a camera is held by the operator or placed on his/her shoulder as oppose to using a tripod, dolly or crane.

Handle. Extra material added to both ends of a print to use for transitions. The same principle applies to digital footage.

Hard Disk. A data storage medium.

Hardware Calibration. A method of using a display calibration system to calibrate a monitor with a device such as a digital camera.

Hays Code, The Motion Picture Production Code. A set of industry censorship guidelines based on moral values that helped censor and control the content released by major studios from 1930 to 1968.

Hazeltine, Color Analyzer. A color-timing machine which determine how to 'time' a film print for the proper amounts of red, blue, and green light.

HDMI. High Definition Multimedia Interface used for transmitting HD Digital Audio and video data.

HDSLR. A DSLR camera capable of capturing HD video. Since most DSLRs today can capture HD video the term had become interchangeable with DSLR.

Head Carpenter. The Head Carpenter.

Head. (1) The beginning of a shot or a roll. (2) The Tripod Head.

Head-On Shot. When an object or subject are moving directly towards the camera.

Headroom. The space between the top of a character's head and the top of the frame.

Helicopter Shot. An aerial moving shot. See Aerial Shot.

Helm. The film's director.

Hero, Heroine. The film's main protagonist.

Hertz, Hz. A unit of measurement used to measure the frequency of musical tones.

Hi Hat. A square plywood tripod-head-mount used for Ground Shots or low shots.

Hi-Con. A very high-contrast film print.

High Concept. A type of film that can easily be pitched with succinctly. *(For example: " Poisonous snakes terrorize a passenger jet.", "A rebellious teen collides with a town where music is banned.", etc.)*

High Definition, HD, High-Def. A general term used to describe a video signal with a resolution higher than that of Standard Definition. Additionally, HD footage is commonly shot on a wider aspect ratio than that of Standard Definition.

High-Angle Shot. When a shot is filmed from above, generally with the use of a crane. Contrast to a Low Angle Shot.

High-Pass Filter. An electronic audio filter used to attenuate all frequencies below a chosen frequency.

Highboy, Overhead Stand. A heavy-duty rolling stand.

Highkey. A well-lit scene consisting of very few shadows.

Highlighting. The use of light beams to illuminate selected part of the subject (such as their eyes) while keeping the rest hidden in shadow.

Hiss. A background noise caused by imperfections in the recording medium.

Histogram. A visual representation of exposure values in an image from dark to bright.

Hitting a Mark. Moving to a marked spot on the floor to allow the camera to smoothly record the action.

HMI, Halogen Metal Incandescence Light. A very bright and powerful light.

HOD. Abbreviation for "Head of Department".

Hold. Used in continuity reports to indicate that a particular take should be kept, but not developed.

Hollywood Box. A stage plug-type box without fuses.

Homage. A way of paying respect to a director by respectfully imitating their work or trademarks.

Honeywagon. A mobile trailer-truck used as the actor's dressing room on-location.

Hoofer. A term for Dancer.

Horror. Unsettling films designed to scare, frighten and panic. *(The Exorcist {1973}, A Nightmare on Elm Street {1984}, The Eye {2002}, The Conjuring {2013}, Insidious {2010}, Audition {1999}, etc.)*

Horse Opera. Slang for a Western.

Hot Points. Called when carrying something big and heavy.

Hot Set. A ready-to-shoot set that should not be changed or disturbed.

Hot Shoe. Used to support external microphones, electronic viewfinders, GPS devices and field monitors.

Hot Splicer. An electric cement splicer.

House Sync. An internal timing signal used to sync devices within a facility

Hue. The attribute of a color.

Hybrid Film. A film combining more than one distinct genre type. *(Fantasy western, horror comedy, live-action animation, etc.)*

Hype, Hyperbole. Overzealous praise or advertising to create buzz and excitement about a project.

Hyperfocal Distance. A distance set on the focusing ring of the lens beyond which all objects can be brought into an "acceptable" focus.

Iconography. The use of a well-known visual symbol or icon.

Illegal Colors. Colors used in a video file which are not supported by the video playback system.

Illustrator. An artist responsible for designing and drawing characters, shots, ideas and visual representations under the supervision of the director or the production designer. Sometimes credited as Concept Artists.

Image Stabilization. An automatic in-camera function of reducing camera shakiness to make the shot appear smoother. Can also be reproduced in post production.

IMAX. Widescreen technology producing an image approximately ten times larger than that of a standard 35mm film (up to 18K).

In point. The edit-point at which a clip begins. See also Out Point.

In-Camera Editing. The process of shooting scenes in the exact order in which they will appear on-tape. It is an amateur way of shooting, often employed by students or experimental filmmakers.

Incident Light Reading. Using a light-meter to measure the amount of light hitting a subject.

Incoming Scene. The second scene to appear in a transition.

Independent Film, Indie, Indie Film. A film production produced outside of the major film studio system. *(Reservoir Dogs {1992}, Lost in Translation {2003}, Slumdog Millionaire {2008}, El mariachi {1992}, etc.)*

Infinity. The furthest possible distance on the focusing ring.

Ingenue. A young, innocent female character. *(Agatha in 'The Grand Budapest Hotel' {2014}, Cecile Caldwell in 'Cruel Intentions' {1999}, Jovie in Elf {2003}, Sandy in Grease {1978}, etc.)*

Ink. Meaning to 'sign' a contract

Inkie. A small fresnel type light.

Inning. A period of time.

Insert edit. Inserting and/or replacing a clip onto a timeline.

Insert Shot. A shot of a subject or object related to on-screen action. *(Such as inserting a shot of a cell phone screen as the character is looking at it).*

Intended Ratio, Original aspect ratio. The original aspect ratio planned. See Aspect Ratio.

Intercut, Intercutting. An editing technique where an editor cuts back and forth between two scenes to make it seem like the actions are occurring simultaneously.

Interior, INT. Used in screenplays to indicates that the following scene occurs indoors.

Interlace. The opposite of Progressive Scanning. In interlace each image consists of two half-height fields as opposed to a single frames.

Interlock. When one or more machines are running in sync.

Interlude. A short, interrupting shot unrelated to the plot or sequence.

Intermediates. A term for color masters or duplicates.

Internegative. A duplicate color negative made from a positive print.

Interpolation. A method used in animation to automatically calculate the motion between two set key-frames so that each frame is not required to be manually animated.

Interpositive. Any positive duplicate of a film used for additional processing.

Intertitle. A single title card occupying the entire screen. Commonly used in silent films.

Intervalometer. An external device used in time-lapse shots.

Into Frame. A subject or object moving into the frame during a static shot.

Invisible Cut. A fast cut made during on-camera motion to seamlessly replace and match the shot, making the cut invisible.

Iris Out, Iris Wipe. The effect of ending a shot with a closing iris circle.

Iris. A variable aperture used to control the amount of light that passes through the lens.

ISO. An in-camera exposure sensitivity settings.

J-Lar. A transparent tape used to splice gels.

Jam Sync. The process of synchronize timecodes between two devices.

Japanese Lantern. An artistic, paper-covered Japanese lamp.

Jib Arm. A mounted counterweighted support arm designed to give the camera a wide range of motion.

Jog. To incrementally scroll through a video by playing it one frame at a time.

Judder. Unstable motion caused as a result of an improper frame rate conversion.

Juicer. Another term for Electrician.

Jump Cut. An abrupt cut intended to communicate the passing of time.

Junior. A 2K light unit.

Juxtaposition. The comparison of two images, characters, objects, or scenes.

Kelvin. A unit of temperature measurement.

KEM. A well known and commonly used Flatbed editing unit. See Flatbed.

Kerning. The horizontal spacing between textual characters.

Key Costumer. Responsible for supervising on-set, wardrobe activities and looking after the cast's wardrobe needs.

Key Grip. Supervises over all grip crews and works with the DP to determine what equipment is needed for each scene or location.

Key Hair. The hair department chief responsible for designing and styling hair for lead actors.

Key Light. The main light used in a lighting set-up. Its purpose is to illuminate the form and dimension of the subject.

Key Make-up Artist. The makeup department head responsible for planning makeup designs for all leading and supporting cast.

Key Numbers. A series of unique identification numbers embedded on the edge of film stock by the manufacturer.

Key Scenic. Responsible for surface looks on set such as special paint and textures. They typically supervise over the painting crew and work to make the set look more realistic.

Keyframe. A marked frame containing animation information.

Keying. A term for removing green-screen / blur-screen chroma key from an image.

Keykode. A machine developed by Kodak to automate the creation of film cut lists.

Kick. An object receiving a shine or bounced light.

Kick-Off. The official start principal photography.

Kiss. A soft light that gently illuminates a subject.

Klieglight. A powerful carbon-arc lamp capable of shining intense light.

L.C.R.S (Left, Center, Right, Surround). The original Dolby Pro Logic format released before the more commonly used 5.1 Surround Format.

Lamp. The bulb inside a lighting unit.

Landmark Film. A revolutionary film recognized by the National Film Registry. *(Matrix, Avatar, Gravity)*

Lap. A dissolve transition effect.

Last Look. A call for final hair/makeup touch-ups before rolling.

Latitude. The range between overexposure and underexposure in which a film appears clear and sharp.

Lavalier, Lavalier Mic, Lavalier Microphone. A small wireless microphone that can easily be hidden in clothing.

Layback. The process of transferring a completed sound mix back into the video master tape.

Layoff. Transfer of audio and timecode from the video edit master to an audio tape.

Layout Artist. A person responsible for staging shots and planning the framing of on-screen action.

Layouts. The process of planning the framing. Not to be confused with Storyboarding.

Layover. The transfer of audio to a multi-track tape or hard disk.

L-cut, Split Cut. A digital film editing cut in which the audio starts before or after the picture.

Lead Character Technical Director. Responsible for character rigs and setups.

Lead Man, Swing Gang. The Set Dressing crew foreman responsible for assisting the Set Decorator.

Lead Role. The main character in a movie.

Leader. A length of material added to the beginning or end of each reel, used for identification, or fill-in purposes.

Legal Color Limiting. Method of clipping electronic signals to conform to user settings *(Maximum and minimum levels)*.

Legal Counsel, Legal Services. The production's entertainment lawyer, responsible for negotiating contracts, clearing licensing rights, obtaining tax credits, etc.

Legal Signal. A signal that must not exceed the specified gamut for the current format. See Gamut.

Leko. An ellipsoidal reflector spot light.

Lens Flare. See Flare.

Lens. A piece of glass in a camera through which light passes before hitting the film stock or sensor inside.

Letterboxing. The placement of black bars at the top and bottom of a Standard Definition image to make it look like a Widescreen format.

Level. A measurement of amplitude in decibels.

Lexan. A flame retardant sheet used to protect crew from explosions or fire effects.

Library Shot. A pre-recorded stock shot. See Stock Footage.

Light Value. A fast opening shutter controlling the light intensity in printing film.

Lighting Board Operator. Electrical Department crew member responsible for controlling the level or intensity of lights on-set.

Lighting Crew. Technicians responsible for installing, operating, and maintaining lights on-set and on-location.

Lighting Department. The department responsible for lighting.

Lighting Technician. A crew-member responsible for setting up and controlling lighting equipment.

Lighting. The manipulation of light and shadows to compose a visually appealing shot.

Lightleak. When a light penetrates through a hole or gap in the body of a camera.

Light-Struck Leader. An exposed leader. See Leader.

Line Producer. A film producer responsible for managing budget and logistics.

Linear Editing. An outdated form of video editing in which the editor selects, arranges and modifies shots in a predetermined sequence.

Lined Script. A shooting script that includes shot and coverage information. See Shooting Script.

Lines. The spoken dialogue (words) by a character in a script.

Lip Sync. The synchronization of mouth movements (image) with recorded audio (sound).

Liquid Gate. A film printing system used to reduce visible surface scratches and abrasions.

Live Area. The complete, unclipped area appearing on a camera's viewfinder.

Loading Booth. A darkroom used for loading film into magazines.

Location Assistant. A crew member responsible for preparing locations and making sure they are ready to accommodate the shoot. They are also responsible for cleaning-up after a shoot is done.

Location, Location Filming, Location Shooting. When filming outdoors on a location not specifically constructed for the production. See Exterior.

Location Manager. A person responsible for securing required permissions for location-shooting.

Location Mixer. A person responsible for mixing sounds recorded on location.

Location Scout. A person responsible for researching and finding suitable locations for filming and presenting them to the director.

Location Sound. See Room Tone or Buzz Track.

Lock It Down, Quiet on the Set. Something a director or AD calls right before speeding when a set needs to be cleared and kept quiet.

Locked Cut, Picture Lock. The approved final cut of a film.

Locked Down Shot. A shot taken with the camera locked-in-place while something is happening off-screen.

Log. A term that can be used to refer to any list or record used to keep track of time, scene descriptions, reel numbers, etc.

Logline. A short, introductory description of what the film is about. Used to sell the concept.

Long Lens. A camera lens which has a focal length that is longer than the diagonal measure of the film or sensor that receives its image. *

Long shot, LS, Full Shot. A shot from great distance. See Wide Shot.

Long Take. A sequence shot over a long period of time such as a long dialogue or uninterrupted action. *(e.g. Kill Bill's long tracking restaurant shot.)* Not to be confused with a Long Shot.

Longitudinal Timecode, LTC. Timecode recorded on a video tape's audio channels.

Look Development Lead. A Visual Effects artist responsible for developing photorealism and rendering for CGI shots and determining which shades, textures and digital tools to use to create desired effects.

Loop. A small magnifier useful in the editing room.

Looping. (1) Another word for ADR. See ADR. (2) A continuous shot or sound that runs repeatedly.

Lossless. A compression format that results in no data-loss and a generally large file.

* Source: Wikipedia

Lossy. The opposite of Lossless Compression. A compression that will result in data loss but a smaller file.

Low Con Print. A low contrast film print.

Low Key Lighting. A high-contrast artistic lighting style using one key light to light a subject and compose a shot as opposed to the traditional Three-Point Lighting. Commonly used in film noir and horror genres.

Low-Angle Shot. A shot in which the camera is positioned at a low angle. Opposite of High Angle Shot.

Lowboy. A heavy duty rolling stand.

Lowpass Filter. An audio filter that blocks the value of frequencies above a specified threshold.

LQV, Luminance Qualified Vector. A vector display device allowing the user to view chrominance and luminance ranges vectors.

Luma Key. Creating a matte based on brightness data in a shot.

Luminance. A measure of brightness or intensity of pixels.

Lyricist. A songwriter.

M&E Track. The abbreviation for 'Music and Effects.' The film's sound-track containing all sounds, effects and music but no dialogue. Used for foreign language dubbing. See Dub.

Macguffin. An unexplained motivator which the main character pursues, oftentimes ignored by the audience and proves to be an important part of the narrative. The term was coined by Alfred Hitchcock. *(The briefcase in 'Pulp Fiction', The ring in 'The Hobbit', Laura in 'Men in Black II', etc.)*

Macro Lens. A lens used for extreme close-shots of a subject or object. Often used to capture small detail. *(Like the eye of a small bug)*

Madcap Comedy, Screwball Comedy. A wild, reckless, fast-paced comedy. *(Caddyshack {1980}, Dinner for Schmucks {2010}, Dumb and Dumber {1994}, The Jerk {1979}, etc.)*

Made-Fors. Short for movies made-for-television. See TV Movie.

Mag, Magazine, Film Magazine. A film-camera chamber that hold up to 1,000 feet of film. One camera can have up to three magazines.

Magic Hour. A term referring to the time of day before or after a sunset, the visual appeal of the colorful sky creates a beautiful backdrop and lighting conditions commonly used for romantic or spiritual scenes.

Magnetic Film, Mag Film. A film on which sound is recorded and from which it can be reproduced.

Mainstream. A film produced for the widest audience possible. *(Iron Man, The Dark Knight, etc.)*

Maintenance Engineer. A crew member responsible for general maintenance and repairs on-set.

Majors. The major Hollywood studios: DreamWorks, MGM, Paramount, 20th Century Fox, Sony, Warner Bros, Universal, and Disney.

Make-up Artist. Make-up artists working under the supervision of the Key Make-up Artist. They are responsible for creating character looks and applying makeup to cast and extras.

Make-up Supervisor. Assisting in running and supervising over the make-up department, keeping records of makeup continuity, handling schedules, etc.

Makeup. The decorations applied to the skin or body of cast-members for either a cosmetic or an artistic effect.

Making of. A Behind the Scenes documentary produced by a Videographer during the production of a film. These are later used as DVD bonus features or as a marketing tool for the film.

Mark. (1) The clapping sound made by the sticks to sync up sound and picture in post production.

Martial-Arts. A film which predominantly feature hand-to-hand combat, often Karate or Kung-fu. *(Fist of Fury {1972}, The Grandmaster {2013}, Bloodsport {1988}, The Man with the Iron Fists {2012}, etc.*

Martini Shot. The last shot of the day.

Mask, Masking. The process of covering-up or blocking a portion of the light, shot, object or frame either on-set or in post production.

Masking, Sound. The act of adding artificial sounds to a track for the purpose of covering up unwanted noise.

Massive. A high-end computer animation and artificial intelligence software used to simulate crowds. Originally used in the *Lord of the Rings* movies to produce battle sequences.

Master, Master Print. A positive print made for duplicating purposes.

Master Shot. A single shot (usually wide) used to film the dramatized sequence while keeping players and location in view. Often used as the establishing shot. See Establishing Shot.

Match Cut. A cut made between two shots to establish a strong continuity of action.

Match Dissolve, Match-Image Cut. A cut or dissolve that aligns two shots that share the same image or frame.

Matchmove, Match Moving, Camera Tracking. The process of tracking and matching the motion of a real, live-action camera with the motion of a computer generated camera in post production. This gives CGI artists the ability to insert 3D elements into live-action footage without needing to manually animate the 3D camera.

Mater. An adjustable clamp used with a variety of accessories.

Matrix Metering. A way for a camera to divide a wide area of the frame into multiple segments and set exposure based on the camera's light meter analysis.

Matte Artist. An artist responsible for creating, matching and integrating digital artwork into a live-action shot.

Matte Box. A square device hooked to a rig rod and placed in front of the lens. It is used to block sunlight and other light sources and prevent glare and lens flare.

Matte Painting. The post production process of adding a digital element to the background of a live-action shot.

Matte Shot. An outdated matte shot created by mounting a piece of glass in front of the camera and adding a strip of black tape to the parts of the glass intended to be replaced. Today, most film-makers use a green screen or a blue-screen and refer to a Matte Shot as a shot that incorporates a Green-Screen.

Maxi-Brute. A high intensity, 9Kw lighting unit used for lighting large areas.

MB, Megabytes. A measurement of computer storage capability. 1MB is equal to 1,000 bytes.

MCU. Medium close-up.

Meat Axe. A grip arm-like clamp.

Medium shot. A conventional camera shot filmed from a medium distance, showing the characters from the waist up.

Megaplex. Large movie theatre that is capable of screening more than two films at a time.

Melodrama. A sub genre of drama films. *(Rain Man {1988}, Marley & Me {2008}, The Notebook {2004}, Big Fish {2003}, etc.)*

Memory Card. A portable, removable device used to store data (footage, audio) captured by digital equipment.

Mercer Clip. A small plastic clip used to hold film ends together during the assembly edit.

Metadata. (1) Content-information embedded into a video file. It is used to inform the user of a video file of the rights, settings, format and other technical information. Also known as Video Metadata. (2) The distribution information related to a film. It is used by an aggregator to populate review sites and online resources. Also known as Distribution Metadata.

Method Acting. An acting method utilizing different techniques for identifying with and "becoming" a character.

Mickey. (1) An open faced 1K lighting unit. (2) A name referring to Mickey Mouse or Disney.

Microphone Impedance. The amount of resistance a microphone has to an audio signal.

Microphone. An audio device used for capturing, converting, recording and storing sound.

Mime. Acting without the use of words, generally restricted to the sole use of facial expressions and gestures.

Miniature. A small-scale model used to give the illusion of a full- scale object.

Mini-Majors. Influential studios which are not as large as the Majors. *(Lionsgate Films, The Weinstein Company, Open Road Films, Relativity Media, etc.)*

Mini-Series. A television series shown in a number of episodes.

Miscast. An actor playing a role they are wrong for.

Mise-en-scene. The factors affecting the artistic look of a shot or scene.

Mix Cue Sheet. See Cue Sheet.

Mix Master. The finished sound mix.

Mix, Sound. All sound tracks and channels combined for the final file delivery.

Mixer. A sound person responsible for sound mixing.

Mixing House. A sound studio exclusive for mixing sound for film.

Mockumentary. A satirical documentary film. *(Forgotten Silver {1995}, The Last Broadcast {1998}, Incident At Loch Ness {2004}, etc.)*

Modeler. An artist responsible for developing 3D objects (characters, buildings, vehicles, people, etc.) via 3D modeling software.

Modern Classic. A very popular, critically-acclaimed film expected to become a cult classic in the future. *(Her {2013}, All Is Lost {2013}, Don Jon {2013}, Spring Breakers {2013}, etc.)*

Mogul. A dominating figure in the film production or distribution business, generally referring to the head of a major or mini-major film studio. *(Jack Warner, Louis B. Mayer, Carl Laemmle, Harvey Weinstein, etc.)*

Moiré. Undesired surface patterns formed in portions of an image, common among DSLR's.

Money Shot. A climatic, cinematic shot designed to be memorable. Oftentimes it is the most expensive shot in the film.

Monitor. A television screen or LCD screen giving the director, cinematographer and focus puller a look at quality of the frame while its being shot.

Monologue. A long speech by a single character.

Montage. An assembly of shots, images and clips put together into a sequence.

Moppet. A child or pre-teen actor.

Morph. The digital transformation and alternation of a digital image or a 3D model.

MOS, Motion Omit Sound. Called before a slate to mark a scene is shot without sound.

Motif. A recurrent theme in a film.

Motion Artifact. Optical distortion caused by the motion of the object, oftentimes because of frame-rate or shutter speed.

Motion-Builder. A 3D character animation software used to capture and transform Motion Capture data.

Motion Blur. Smeared on-camera movement caused by quick motion recorded at a low shutter speed.

Motion Capture. A method of capturing real-world motion (including facial expressions) and digitally convert the information for use in a 3D application.

Motion Control Technician. A technician responsible for operating motion control rigs.

Motion Control. A way of setting up and replicating camera motions and movement for VFX sync or handling complex motions that cannot be handled by an operator.

Motion Picture Association of America, MPAA. An organization that rates a film's suitability for certain audiences. See Rating.

Motion Picture Editors Guild. A professional union for picture and sound editors.

Motion Pictures. Another term for movie.

Moviola. An upright film editing machine.

MS. Medium shot, waist to head.

Multichannel. Employing more than one channel.

Multi-Track. More than two audio tracks.

Musco Lights. HMI lights mounted on a crane.

Music Editor. An person responsible for editing the musical score.

Music Preparation. A person responsible for printing and preparing parts of the score for the musicians to play from during a score recording sessions.

Music Supervisor. A person responsible for co-ordinating the musical score and obtaining the rights for pre-recorded materials for use in the film.

Musical. A film genre that tells the story through signing. *(The Sound of Music {1965}, Moulin Rouge! {2001}, Les Misérables {2012}, Sweeney Todd: The Demon Barber of Fleet Street {2007}, etc.)*

Muslin. A very soft diffusion material used for bouncing. See Light Bounce.

Mute. A picture-only print.

MXF, Material eXchange Format. A "container" format used to store video, audio and metadata.

Narration. The telling of a story by an off-screen voice known as the Narrator.

Narrative Film. A story structure following a series of dramatic events to their conclusion.

National Association of Theatre Owners, NATO. A trade organization representing the largest movie theater owners in the United States.

NC.17. A rating issued by the MPAA stating that a film is not appropriate for anyone under the age of 17.

Negative Cost. The cost of producing a film from inception to a finished negative.

Negative Cutter, Negative Matcher. A person who cuts and splices the negative to the final version of the film.

Negative Pick-Up. A distribution clause requiring the delivery of the finished film before an advance can be paid by the distributor.

Negative Print. A reverse light image capture.

Negative Ratio. The aspect ratio of the negative.

Negative. The original film from which a positive print is made for editing

Neo-Realism. A naturalistic movement that emerged in the 1940s.

Nets. A bobbinet on a frame used to cut lighting intensity.

Network TV. A telecommunications network for distributing television programs and other content.

Neutral Density, ND. A lens filter used to reduce the intensity of light. *(Like sunglasses for the lens.)*

New Deal. Changing the camera lens or position setup.

New Wave. New Wave of filmmakers of the late 1950s and 1960s.

Newsreel. A filmed news report.

Nifty Fifty. A 50mm lens.

Nihilistic. A dark, depressing film. *(Kids {1995}, Funny Games {2007}, Melancholia {2011}, Naked {1993}, etc.)*

Ninja Blade Recorder, The Ninja. A production recorder, monitor and playback deck.

Nitrate Film Base. A highly-flammable type of film base.

NLE. Non-Linear Editing.

No Animals Were Harmed. A trademarked certification by the American Humane Association.

No Good. A call for a second take.

Noir. See Film Noir.

Noise Reduction. The process of digitally removing or suppressing unwanted artifacts in an image or sound.

Noise. Undesired electrical interference in audio or video. See Artifact.

Non-Linear Editing. The process of editing a film without the need to assemble it in linear sequence.

Non-Reflex. A camera in which the viewfinder is viewed via a separate lens.

Non-Speaking Role. A small, non-speaking role in a film.

Non-Sync. A scene shot without synced sound.

Non-Traditional Casting. The casting of minority in racially undefined roles.

Normal Lens. A lens that reproduces a "normal" field of view as compared to longer or shorter lenses which produce an expanded or distorted field of view.

Nose Room. The space between the edge of a character's nose and the edge of the frame.

Nostalgia Film. A film that celebrates the past. *(Midnight In Paris {2011}, Dazed And Confused {1993}. The Sandlot {1993}, The Artist {2011}, etc.)*

Novelization. Making a novel from a film or screenplay

NTSC, National Television Standards Committee. The standard for TV/video display in the US and Canada

Nut, House Nut. The theater's operating costs.

O.C.N. Original Color Negative.

Obie. An eye-light mounted on a camera.

Obligatory Scene. An "expected" shot or sequence for a particular genre.

Off Book. When an actor no longer need to read off the script.

Off Mik. A call to inform the director that dialogue was not properly picked up by the microphone.

Offline Edit. Editing a film with low-resolution proxies to increase the editing unit performance.

Offstage, Off-Camera. Any action or dialogue occurring beyond the boundaries of the frame, off-screen.

OMF, Open Media Framework. A file format intended for transferring media between different software applications on different platforms. *

One Light. One light source in the shot.

One Man Show, One Woman Show. A feature film or a short featuring a single performer. *(All Is Lost {2013}, Moon {2009}, Wrecked {2010}, etc.)*

One-Light Print. A film print made with a single printer light setting.

One-Liner. A one-line punch line.

One-Reeler. A film shorter than 13 minutes.

* Source: Wikipedia

One-Reeler. A film shorter than 13 minutes.

One-Sheet. A single document or poster that summarizes the film for publicity and sales.

Online Edit. After an offline edit is complete, the low resolution proxy is replaced with raw, high-resolution media. (See Offline Edit, Proxy).

Online Editor. An editor who performs the on-line edit.

OOF. Shot is out of focus.

OOV. Out of vision. Dialogue is heard but the speaker is out of frame (off-screen).

Opacity. The level of transparency in an image, recorded in the alpha channel.

Opaque Leader. A strip of flexible material used to space picture in A/B roll film cutting and editing.

Opaquer. In animations, the Opaquer is responsible for coloring individual cells. See Cell.

Opening Credits. The opening credits sequence. See Credits.

Opening Weekend. The period at which a film is released to theaters. Opening Weekend Gross measures the revenue generated during the film's first weekend in theaters.

Optical Effects. Fades, dissolves and other effects created at a film laboratory.

Optical Printer. An optical printer used for making special effects for motion pictures, or for copying and restoring old film material.*

Optical Resolution. The resolution at which a device can capture an image.

Optical Sound. The means of storing sound recordings on transparent film.

Optical Soundtrack. An analog soundtrack printed on film.

Optical Zoom. Another name for a zoom lens.

Opticals. Shots and effects produced through Optical Printing.

Option. The exercisable right to acquire the rights to a script within a specific time-frame.

Orange Stick. The preferable way to clean a gate.

Original. The original film negative as opposed to a print.

Oscar Bait. A film perceived as a serious contender for an Academy Award. Also known as Frunt-runner. *(Captain Phillips {2013}, Saving Mr. Banks {2013}, The Book Thief {2013}, etc.)*

Oscar, Oscars, Academy Awards. See Academy Awards.

OSS, OS. Over the Shoulder shot.

Out Point. The point at which a clip ends in the editing timeline. See also In point.

Outgoing Scene. The first out of 2 scene in a transition effect.

Out-Take, Outtakes. An unused take. See Bloopers.

Over the Shoulder, OTS. A common medium shot in conversations.

Overacting. Poor, over-the-top acting.

Overages. Payments made to the producer by the distributor after the advance has been recouped.

Overcrank. To run the camera faster, shooting more than 24fps.

Overexposure. Filming a scene with too much light, which results in the photograph being too bright and loss of detail.

Overlap. To carry-over dialogue, sounds, or music from one scene to another.

Overture. A pre-credits musical selection that sets the mood for the film.

Overwrite Edit. To overwrite clips when adding a new clip onto a timeline.

P&A Commitment. A contractual obligation by a distributor to spend a predefined sum on P&A to support the theatrical release of a film.

P&A. Prints and Advertising, the biggest costs associated with film distribution.

POV, Point of View Shot. A shot from the perspective of a characters.

PA. A personal assistance.

Pace. The tempo and speed of a dramatic action.

Package. A combination of several creative elements in a film such as a script, guarantees, cast, locations, etc. Used to attract interest in the production, guarantee distribution or secure financing.

PAL, Phase Alternating Line. The European color television standard.

Pan and Scan. A method of converting widescreen to a 4.1 aspect ratio by cropping the image.

Pan, Panning Shot. Abbreviation for Panorama Shot. A horizontal camera move on an axis.

Pancake. A size of apple box.

Paper Tape. A roll of tape used during film editing.

Parallax. The distinction between the image projected and the image recorded.

Parallel Editing. The technique of inter-cutting between two simultaneous scenes at different locations or different times.

Parallels. Temporary scaffolding used as rig platforms.

Parody. A comedy that imitates or makes fun of a subject/film/story in an absurd, exaggerated way. *(Scary Movie {2000}, Airplane! {1980}, The Naked Gun {1988}, Dracula: Dead and Loving It {1995}, etc.)*

Pay or Play. When a production company guarantees compensation to a cast or crew member whether or not the film gets green lighted.

Payoff. A dramatic scene that justifies everything that preceded it.

Payola. Under-the-table payments.

PC Sync. A standardized connector used to sync external flash units to cameras.

Pen. To write a script.

Performance Capture. A full-body Motion Capture (body, hands, face, etc.).

PG, Parental Guidance Suggested. MPAA ratings indicating that a film's content is suitable for viewing by children with parental guidance.

PG.13. MPAA ratings indicating that a movie's content is rated as slightly stronger than a PG certificate. See also R.

Phantom Power. Powering microphones directly through the camera instead of a separate power supply.

Phase shift. The displacement of a waveform in time. Some electrical components introduce phase shift into a signal.

Phase. The timing relationship between two signals.

Photo Flood. A high power screw-in light bulb.

Pickup Shot, Reshoots. Reshooting shots or scenes after production wraps.

Picture Car. Any vehicle shown on-screen.

Picture in Picture, PIP. An effect where a small window of footage is superimposed over a larger window.

Picture's Up. Call by the camera operator to alert the director that the camera is ready to start rolling

Pigeon. A heavy round disc with a lighting stud. See Hi Hat.

Pillarbox. Black bars displayed at the sides of the screen when a 4.3 image is shown in widescreen.

Pincushion Distortion. The opposite of barrel distortion. Common in cheap lenses.

Pin-up Girl. A model whose mass-produced pictures see wide appeal as popular culture. ★ (Bettie Page, Betty Grable, Dita Von Teese)

Pipeline. A schedule of movie projects in production.

Pitch. (1) A proposal to secure financing or gain support for a film. (2) The distance between two successive perforations along a strip of film. (3) The frequency of audible sound.

Pixel Aspect Ratio, PAR. The ratio of the width of a pixel to its height.

Pixel. Small components that collectively recreate the image captured with a digital camera.

Pixelation. Large, square-like pixels in an image caused by scaling. Can also be created digitally for censorship or to maintain the anonymity of a subject.

Plate Shot. (1) A background shot with no foreground elements. (2) A name referring to the live-action footage shots used in CGI and visual effects.

Playback. Playing music through loudspeakers while performers dance, sing, etc.

Pledge Holder Agreement. A guarantee by a laboratory to a financing company to not release materials without their written consent.

Plot Point. A significant event in the story that shifts the action in another direction.

PNG. A common format used for lossless compression.

Points. A share of the net-profit (back-end).

Polyester Base. A highly durable type of film.

Positive Print. A film print created from a negative suitable for projection.

Post Production Coordinator. Responsible for the smooth operation of post production.

Post Production Supervisor. The person in charge of the Post Production department. They oversee the entire post production project and work directly with the studio/producer.

Post Production, Post. The final stages of the filmmaking process. Post production includes all the work done after principle photography. Includes editing, ADR, sound design, credits, visual effects, film transfers, etc.

Post Credits Sequence. A bonus scene running during or after the end credit.

Practical Light. Any light that appears in a shot.

Preamplifier. An electronic device for boosting weak signal.

Pre-Code. See Hay Code.

Premiere. The first official public screening of a film.

Premise. The main idea or concept behind the film.

Pre-Production. The planning stage in a film before principle photography begins. The planning stage includes casting, location scouting and budgeting.

Prequel. A film containing events preceding those of an existing work. Contrast with sequel.

Preroll. A stretch of time running at the beginning of a sound take to accommodate slow VTR or camera.

Pre-Sale. Selling a film (to an agent, distributor or to an audience) before it is released or complete.

Prescoring. Recording music before a sequence is available to accompany it.

Pre-Screen. To watch a film before it is released for the public.

Pressure Plate. Located on the other side of the film from the gate, located inside the camera.

Preview. See Trailer.

Previsualization Artist, Previz Artist. A designer who uses low resolution proxy models to conceptualize a VFX sequence.

Primary Grading. Color grading that affects the overall color balance of an image. See Color Grading.

Prime Lens. A lens with a single focal length as opposed to a Zoom Lens. Prime lenses tend to be sharper and faster than zoom lenses.

Principal Photography. The period of main photography of the film.

Principals. The main characters in a film.

Print Stock. Film used by the lab for making copies.

Print. A positive copy of the film intended for projection, consisting of one or more reels.

Private Investor. An individual who invests his own money in a film.

Process Shot. A shot of live action in front of a projection.

Producer. Responsible for managing the production from start to finish.

Product Placement. The way companies buy advertising space within a film for their products by signing a Product Placement contract. The filmmakers agree to show a product or logo in return for compensation, payment or sponsorship.

Production Accountant. A person responsible for managing the money and keeping the production on-budget. See Line Producer, Accountant.

Production Assistant. A person responsible for various odd jobs. See PA.

Production Buyer. The person responsible for purchasing supplies, equipment and props, among others.

Production Code. See Hays Production Code.

Production Company. A company allocating resources for the production of a film. (Production space, producers and funding).

Production Coordinator. A person responsible for organizing logistics, hiring crew, dealing with rentals, bookings, etc.

Production Design. The film's overall design, continuity, visual look and composition. The production designer is responsible for designing the overall visual appearance of a movie.

Production Dupe. A duplicate negative.

Production Illustrator. An artist responsible for drawing storyboards.

Production Manager. A producer working under the film's chief producer, they are in-charge of the physical aspects of the production and to keep the production on-budget, among others.

Production Report. A daily progress report.

Production Schedule. A detailed plan of the timing of activities associated with the making of a movie, of particular interest to production managers.

Production Secretary. Secretary to the production manager.

Production Sound Mixer. The head of the sound department on the set.

Production Sound. Audio recorded and mixed on set.

Production Value. The quality of the production in regards to elements such as camera movements, colors, quality, style, etc.

Production. The general term describing the processes involved in filmmaking, from start to finish.

Progressive. As opposed to Interlace, Progressive scanning processes each frame as one complete image.

Projection Leader. See Leader.

Projectionist. A person who operates a projector.

Projector. A device for projecting movies on screen (film or digital).

Prologue. A brief introduction scene preceding the main action or plot of a film.

Promo. Slang term for sales promotion

Prompter. A person supplying actors with the correct lines from the script if they forget.

Prop Assistant. A person responsible for the placement and maintenance of props on a set.

Prop. Abbreviation for properties. Any object that an actor touches or uses on the set. (furnishings, fixtures, food, decorations, etc.)

Property Master. A person responsible for buying or building the props that are used for the film.

Prosthetic Appliances, Prosthetics, Prosthetic Makeup, FX prosthesis. The process of using prosthetic sculpting, molding and casting techniques to create advanced cosmetic effects.

Protagonist. The main hero character in the film; contrast to antagonist.

Publicity Assistant. Assistant to the publicity director.

Publicity Department, Advertising. The department responsible for marketing and promoting a movie in the press.

Proxy: A low resolution, highly compressed video file that mirrors a high resolution master. Used in online/offline editing. See Online Editing, Offline Editing.

Publicity Director, Publicity Executive. A person responsible for overseeing the film's publicity campaign.

Pull Back. A shot where the camera moves away from the subject to reveal the full context of the scene.

Pull Down. The practice of converting 24fps film to interlaced 30 fps NTSC.

Pull Focus, Rack Focus. See Focus Puller.

Pull Processing. The process of quickly developing film quickly.

Pyrotechnician. A person responsible for the handling and operating of pyrotechnics, they regularly handle explosives and other special effects.

Q rating. A rating that indicates how easily a celebrity is recognized.

QRP. Quick release plate

Quarter. A quarter of a year. Used by distribution and production companies for financial accounting.

Quartz Light. Tungsten-Halogen lights or lighting units.

Quick Release Plate. Used for quickly mounting and removing the camera from the tripod.

Quick Release Shoe. A part of the quick release plate that attaches to the camera.

QuickTime. A Cross-platform video compression software developed by Apple to support the MOV file.

R, Restricted. A certificate issued by the MPAA indicating that people under 17 years may only be admitted if accompanied by a parent or guardian.

Rack Focus. The technique of shifting the focus from a subject in the foreground to a subject in the background and vice versa.

Rack. Storage area for computer servers and other equipment.

Rating System, Ratings. Designated to classify films with regard to suitability for audiences in terms of issues such as sex, violence, substance abuse, profanity, impudence or other types of mature content.*

RAW, Clean HDMI. Uncompressed footage.

Raw Stock. Unexposed film.

Reaction Shot. A quick cut to a character reacting to the events of the scene.

Real Time. The actual time it would take for an event to occur in real life.

Rear Projection. An alternative to green screen / blue screen using real background projected onto the screen behind the actors.

Recans. Leftover film loaded into a magazine but never used.

Red Carpet. A long red carpet laid on the ground for distinguished visitors to walk on when arriving at a film premiere, award ceremony, etc.

Red Herring. Something that misleads or distracts the audience from the plot. Contrast to McGuffin

Redhead, Mickey. An open faced 1K lighting unit.

Redlighted, Turnaround. A film pulled from production and abandoned by the studio.

Redrock. Manufacturer of rigs and accessories.

Reduction Print, Reduction Printing. Transferring a film to a smaller gauge *(e.g. 35mm to 16mm)*.

Reel. A metal wheel attached to a projector. Used to wind up motion-picture film. One reel is about 10 minutes of running time.

Reference Tone. An audio tone used to sync playback audio volume.

Reflective Light Reading. Measuring the amount of light bouncing off the subject.

Reflex. An in-camera viewfinding system where the image in the viewfinder is viewed through the same lens that is used to photograph the image on film.

Registration Pin. In-camera mechanism used to steady the image during exposure.

Registration. The degree to which one frame lines up with the next.

Reissue. A studio releasing a work subsequent to the original release. Similar to re-release.

Relational Editing. The process of comparing and contrasting shots during editing.

Release Print. A print made after the answer print has been approved.

Release. The first theatrical distribution to general public exhibition.

Remake. A new version of a film's narrative and subject matter.

Render Farm. A group of high-performance computers devoted to rendering images, used primarily to render visual effects shots, CGI sequences and computer-animated films.

Render. The process of outputting computer generated effects or animation for playback or final output.

Rentals. Refers to film revenue generated by DVD and Blu-Ray rentals.

Re-recording Mixer. A crew member responsible for balancing and mixing the final sound elements such as dialogue, music, sound effects and foley.

Re-release. The revival or rebroadcast of a work by the original distributor or studio. *(Jurassic Park 3D {2013}, Titanic 3D {2012}, etc.)*

Reshoot Contingency. Funds in the budget designated for supplementary shootings, if needed.

Residuals. Money payable to an actor, musician, writer, director, etc.

Resolution. (1) The amount of data used to capture and play a digital file (video/audio). The higher the resolution, the finer the detail. (2) The outcome of a dramatic sequence.

Resolver. A device that governs the speed of a tape recorder during the transfer to mag, insuring the sound will be in sync with picture.

Retrospective. A comprehensive compilation or montage of previous work.

Reverberation. A reflection of a sound from multiple surfaces. This is in contrast to an echo, where there is generally only one surface reflecting the sound and the echoed sound is much clearer. Reverberation is the presence or persistence of sound due to repeated reflections.

Reversal film. A film that produces a positive image after exposure.

Reversal Original. A reversal film designed to be exposed in a camera.

Reverse Action. An optical effect in which the action appears backwards from its chronological sequence.

Reverse Angle Shot. A shot that turned 180 degrees in relation to the preceding shot.

Reverse Motion. The effect of running film backwards in the camera or during optical printing.

Revisionistic. A sub-genre of Western. *(True Grit {2010}, The Lone Ranger {2013}, There Will Be Blood {2007} 3:10 to Yuma {2007}, etc.)*

Revival House. A film theatre dedicated to emphasizing or specializing in only one type of film. *(i.e. foreign films, older films, silent films, classics, rarely-screened films, etc.)*

Rewinds. A simple device for winding film.

RGB Color, Red Green Blue. Digital devices handle color information as shades of red, green and blue.

RGB Parade. A waveform display of the video levels for Red, Green and Blue components.

RGB. The primary colors of light used to make images in monitors, cameras and digital projectors.

RGBA. A file containing an RGB image plus an alpha channel for transparency information.

Rig. A system designed to support DSLR cameras for independent filmmakers.

Rigger. Crew member responsible for setting up lighting and scaffolding on film sets.

Rim Light. A hard backlight.

Ripple Edit. An editing technique where adjusting the length of a clip causes clips further down the timeline to move to accommodate the change.

Riser. (1) A cylindrical metal device placed between the dolly head and the camera base to raise the camera. (2) A prebuilt platform used to raise the set, camera, or lights.

Rivas. A type of tape splicer which uses perforated splicing tape. Two models exist. One for straight cuts used for picture, and one for slanted cuts used for sound.

RMS, Root-Mean-Square. A measurement of sound pressure.

Roadshow. A controversial exploitation film, heavily promoted and shown on the road.

Roll Edit. A method of shortening one clip and lengthening an adjacent one at the same time in order to maintain the original length of the sequence.

Room Tone. Background sound (room noise) recorded on set and used during the sound editing process.

Rotation Shot. A complete (or half) circle spinning camera motion.

Rotoscoping. The process of tracing the outlines of live action elements frame by frame, normally used for matte effects.

Rough Cut. An early edited version of the film. Also known as First Cut.

Royalty Payments: A payment made to the legal owner of copyrighted work.

Running Time. The duration or length of a film.

Rush. See Dailies.

SMPTE Leader. Another term for Academy Leader.

Safe Area. The specific portion of the frame indicating what will appear in the final product.

Safety. An additional backup take.

Sales Agent. A person responsible for selling film rights on behalf of the producer.

Sandbag, Sand. A sand-filled cloth bag used as weights to keep light stands from moving or falling.

Satire. A humorous film mocking and ridiculing a subject. *(The Man Who Knew Too Little {1997}, The Player {1992}, Tropic Thunder {2008}, etc.)*

Saturation. A measure of color depth and volume within an image.

Scenario. A screenplay outline.

Scene Chewing. A dominating, emotional performance by an actor, often overdone.

Scene. A series of shots edited together to comprise a coherent dramatic sequence.

Scenery. The visual environment of a shot, most often referring to a backdrop or background.

Scene-Stealing. A character whose performance draws more attention from the audience than other actors in the same scene. *(Will Ferrell in Wedding Crashers {2005}, Eugene Levy in American Pie {1999}, etc.)*

Scenic Artist. An artist responsible for the scenic painting on set, including the use of textures, colors and surface aging.

Scope. Another name for size.

Score. The original musical component of a film's soundtrack.

Scratch Mix, Scratch Track. A raw sync mix with no post processing.

Scratch Test. The process of checking a film for scratches before loading it to a magazine.

Scratch. Physical damage caused to a film.

Screen Actors Guild, SAG. A labor union representing film and television performers.

Screen Direction. The direction in which a character or object is moving in the frame.

Screen Test. An audition performed by a potential actor on-camera.

Screener. A promotional DVD or digital copy of a completed film sent to film critics or Academy voters to solicit reviews / votes.

Screening. The exhibition of a film in a cinema prior to its release, generally during a private event.

Screenplay. Another word for script. See Script.

Screenwriter. A freelance writer who writes movies materials for film production.

Scrim. A metal filter mounted on a light to decrease its intensity.

Script Department. A department responsible for the script of a movie.

Script Editing, Story Editor. A process whereby a script is reviewed and changed.

Script Supervisor. A person who keeps track of the shots and continuity.

Script. A screenplay, shooting script, lined script, continuity script, or a spec script.

Scripty. The script supervisor.

Scrub Wheel. A mechanical control for scrubbing film or magnetic tape.

Scrub. Moving a piece of tape or magnetic film back and forth over a sound head to locate a specific point in the shot.

SD Card, Secure Digital. Removable memory commonly found in DSLR cameras. Newer-generation SD cards include SDHC and SDXC memory cards.

SDDS. Sony Dynamic Digital Sound System. A film sound format which encodes eight tracks of digital audio outside of the sprocket holes on both edges of a film print.

Seamstress. A person who makes the costumes.

Second Assistant Camera. An assistant to the assistant cameraman.

Second Assistant Director. The chief assistant of the 1st AD.

Second Banana. An actor who plays a subordinate or secondary role.

Second Second Assistant Director. Responsible for directing extras, among others.

Second Sticks. A call made to inform the 2nd AC that the clap of the slate sticks was not properly captured and is needed again

Second Unit Director. The director of the second unit.

Second Unit. A team responsible for shooting secondary scenes such as stunts, inserts, crowds, scenery, car chases, or establishing shots.

Secondary Grading. Color grading that produces a specific color range or effect.

Segment. A series of sequences that comprise a major section of the plot.

Selects. Shots selected for use before editing begins.

Senior Stand. A braced junior stand sufficiently rugged for large lights.

Senior. A 5K fresnel lighting unit.

Sensitivity. The capacity of a microphone or a sensor to respond to sound/light.

Sepia Tone. A black-and-white image converted to a sepia tone or color.

Sequel. A movie that presents the continuation of characters, settings, or events of a previously filmed movie.

Sequence. A connected series of related shots edited together.

Serial. A multi-part film screened each week at a cinema, popular between 1912 and 1945.

Set Decorator. A person responsible for decorating the film set.

Set Designer. The person responsible for translating the designer's vision and creating sets for use in the production of films.

Set Dresser. A person who maintains the set. Responsible for set continuity.

Set Dressing. Items of decoration in a scene not specifically mentioned in the script.

Set Medic. Provides for the medical needs and emergency medical logistics of the cast and crew.

Set Up. The position of the camera and lights when shooting a scene.

Set. The environment artificially constructed for filming.

Set-Piece. A self-contained, elaborate scene or sequence that stands on its own.

Setting. The time and place in which the film's story occurs.

Sexploitation. A non-pornographic film that feature sexual themes or explicit sexual material and nudity. *(The Candy Snatchers {1973}, Black Snake Moan {2006}, I Spit on Your Grave {1978}, etc.)*

SGO Mistika. A post-production color grading and effects software used in professional film.

Shammy. An eyepiece chamois.

Sharpie. A marker useful for labeling cans of exposed rolls, labeling the slate and marking focus on the follow focus ring.

Sharp. Focus, used as a noun.

Shiny Boards. A grip reflector used for key or fill light.

Shoot and Protect. A technique in which material is shot in such a way that the areas of interest within a frame lie within a rectangular "protected area" within the frame, with margins at top and bottom and both sides. *

Shoot. The filming process.

Shooting Day. The day of filming on-set.

Shooting Ratio. The ratio between how much film was shot versus how much was used in the final version on the film.

Shooting Script. The technical script from which a movie is made.

Shop Steward. Represents the crew in dealings with production management.

Short. A film shorter than 45 minutes.

Shortends. The unexposed remainder in a magazine clipped and placed back into a can for use later.

Shot Composition. The arrangement of key elements within the frame.

Shot List. A list indicating the sequence of scenes being shot for the day.

Shot. A single sequence of film or digital footage made by a camera and uninterrupted by an edit.

Shotgun Mic. A directional microphone with a narrow-angle range of sensitivity.

Shotlister. A phone application used for the creation of shot lists.

Showcard. A cardboard used as a reflector or for making other special rigs. It is easily cut and formed.

Shutter Priority. A metering mode in which the shutter speed is fixed and the exposure is controlled by opening or closing the lens aperture.

Shutter Speed. The amount of time it takes for the camera shutter to open and close.

Shutter. The part of a camera that opens to allow light to make contact with the sensor.

Siamese. A splitter that divides a power line into two parts.

Sibilance. An exaggerated hissing in voice patterns.

Sider. A device which cuts the light from the side of a lighting unit, usually a flag or a cutter.

Sides. A half-sized script that contains the scenes being shot for that day.

Sight Gag, Visual Gag. Non-verbal, physical humor.

Sight Line. An imaginary line drawn between a subject and the object that they are looking at.

Sign Writer. The person in charge of creating signs shown in a production.

Signal to Noise Ratio. The ratio of the desired signal to the unwanted noise in an audio or video record/playback system.

Signal. An electrical impulse or radio wave transmitted or received.

Silent Camera. A very noisy film camera.

Silent Film. A film that has no synchronized soundtrack and no spoken dialogue. Contrast with talkies. *(The Birth of a Nation {1915}, The Phantom of the Opera {1925}, The Artist {2011}, etc.)*

Silent Speed. A term referring to 18 frames per second.

Silk. A material used to diffuse or reflect light.

Silver Bullet. A solution that completely solves the complicated dramatic problem within a film.

Singer. A featured vocalist.

Single Perf. 16mm film with a row of perforations along one edge.

Single Reel. In 35mm a reel is 1,000 feet of film.

Single System. A method of recording, editing and projecting sound and picture on the same medium.

Single. A shot with only one subject in the frame.

Single-Stripe. Magnetic film containing a single audio track, coated with oxide.

Sketch. A short scene that typically lasts less than 15 minutes.

Skip Frame. Cutting or skipping selected frames to speed up the action.

Slapstick. A broad form of comedy in which the humor comes from physical acts or pantomime. *(There's Something About Mary {1998}, Tommy Boy {1995}, Ace Ventura: Pet Detective {1994}, Scary Movie 3 {2003}, The Return of the Pink Panther {1975}, etc.)*

Slasher film. A sub-genre of horror film, typically involving a mysterious, generally psychopathic killer stalking and killing a sequence of victims usually in a graphically violent manner. *(Halloween {1978}, The Texas Chainsaw Massacre {1974}, A Nightmare on Elm Street {1984}, Friday the 13th {1980}, Psycho {1960}, etc.)*

Slate, Clapper. See Clapboard.

Slate. Shot information placed in front of the camera via the clapper board.

Slave. An audio tape or videotape transport.

Sleeper. An unpromising or unpublicized movie that eventually becomes popular or financially successful beyond expectations.

Slop Print. An untimed black and white dupe print used for projection in a sound mix.

Slow Motion. A shot in which time appears to move slower than normal.

SLR, Single-Lens-Reflex. A single-lens reflex camera uses a mirror and prism system that permits the photographer to view through the lens and see exactly what will be captured, contrary to viewfinder cameras where the image could be significantly different from what will be captured. *

Slug Line, Slug. (1) A header appearing in a script before each scene or shot detailing the location, date, and time that the following action is intended to occur in. (2) Another name for Filler. (3) A strip of film or digital effect used to fill in black areas on the timeline.

Smart Side. Looking in the same direction as the lens, the left side of the camera

Smash-Cut. An abrupt, jarring and unexpected change in the scene.

SMPTE Timecode. A set of cooperating standards to label individual frames of video or film with a time code defined by the Society of Motion Picture and Television Engineers. *

SMPTE, Society of Motion Picture and Television Engineers. A film and television standards group that, among other things, standardized the use of SMPTE timecode.

Snake. A multi-channel audio cable.

Sneak Preview. A screening of a film before its premiere.

Soft Light. Light that tends to "wrap" around objects, casting diffuse shadows with soft edges.

Soft Sticks. A phrase called by the clapper loader when circumstances force a tight clap, sometimes inches away from an actor's face.

Soft Tape. A cloth tape measure.

Soft-Focus. When a filter is placed over the lens to reduce the clarity or sharpness of focus.

Softie. The first AC or focus puller.

Soliloquy. A dramatic monologue delivered by a single actor with no one else onstage.

Sony Dynamic Digital Sound. A noise reduction and sound enhancement process by Sony.

Sound Blanket. Thrown over noisy items. See Blanket.

Sound Crew. Crew-members responsible for creating the film's soundtrack. *(Sound designer, sound editor, sound effects, sound mixer, foley, boom operator, etc.)*

Sound Designer. A sound specialist responsible for the development of the film's sound.

Sound Effect. A sound that matches the visual action taking place on-screen.

Sound Effects Editor. Sound editor specializing in editing sound effects.

Sound Fill. See Filler.

Sound Master Positive. A sound print made for producing duplicate negatives.

Sound Mix. The process of recording the production sound on the set during shooting.

Sound Mixer. A person responsible for recording and mixing production sound on set.

Sound Negative. A negative sound image on film.

Sound Speed. 24 frames per second.

Sound. See Audio.

Soundstage. A large space in a studio where elaborate sets may be constructed.

Soundtrack. The audio component of a film, including the dialogue, musical score, narration, sound effects, etc.

Source Material. The original work on which the screenplay is based. *(Novel, game, etc.)*

Source Music. Music originating from a source within the scene.

Spaghetti Western. A western filmed in Italy, many times with American leading actors. *(Django Unchained {2012}, The Good, the Bad and the Ugly {1966}, The Great Silence {1968}, A Fistful of Dollars {1964}, etc.)*

Sparks. An electrician. See Juicer.

Speaking Role. A speaking role in which the character speaks scripted dialogue.

Spearhead Display. Allows the color corrector to perform color adjustments for lightness, saturation and value.

Spec Script. A non-commissioned script send for consideration.

Special Effects Assistant. Responsible for carrying out the instructions of the Special Effects Supervisor.

Special Effects Supervisor. Responsible for designing moving set elements and props that will safely break, explode, burn, collapse and implode without destroying the film set or harming the crew.

Special effects, SFX. On-camera effects as oppose to visual effects created in post production.

Special Effects. A department responsible for the practical or physical effects during live-action shooting.

Special Makeup Effects. The use of wigs, makeup, prosthetics and other tools to create a desired look on-screen.

Specifics. Any sound effects that directly relate to the picture.

Specular Highlights. The bright spot of light that appears on shiny objects when illuminated.

Specular. Highly directional, focused "hard" light.

Speed. A call by the camera operator or boom operator to acknowledge that the equipment is running (rolling).

Speedgrade. A color correction and grading software.

Spider. A term for Spreader. See Spreader.

Spikes. Small pieces of tape placed around the legs of a tripod, making it easy to return them to their original position.

Spill. Unwanted light, such as green light being reflected from a green screen onto a subject.

Spin-Off. A new film or TV show derived from an existing product or franchise.

Splice. A method of joining two pieces of film.

Splicing Tape. A special type of clear tape used to splice film.

Split Screen. Dividing the screen into two or more actions with different shots in each section.

Spoiler. Information about the plot or ending that may ruin the enjoyment of the film.

Spoof. A comedic film that pays tribute to an earlier film in a humorous way. *(Scary Movie {2000}, Young Frankenstein {1974}, Top Secret! {1984}, Walk Hard: The Dewey Cox Story {2007}, etc.)*

Spool. A roll on which film is wound.

Spot Meter. A type of meter for taking a Reflective Light Reading.

Spot Metering. The measurement of small areas of the total picture area.

Spotting. The process of analyzing and identifying the specific scenes or points where music cues or effects cues will take place.

Spreader. A piece of gear consisting of three arms attached to the bottom of a tripod to keep the legs from collapsing outwards.

Spring Lock. A round clamp that goes on the end of a rewind to allow several reels to turn together.

Sprocket. Geared wheels used to wind film through a mechanism into a camera or projector.

Spun. Glass diffusion material. See Diffusion.

Squawk Box. A small amplified speaker used on an editing bench.

Squib, Blood Pack. A small explosive device simulating the effect of a bullet puncture wound or small explosion. Can also include a container of blood which bursts upon detonation.

Stabilization. See Image Stabilization.

Stage Box. A distribution box with six pockets for stage plug connectors.

Standard Definition (SD). Television broadcasting standard with a lower resolution than high definition.

Standards Conversion. The process of converting a television standard.

Standby Painter. A scenic artist on standby for last minute changes.

Stand-In. A person who takes the place of an actor during the scene setup.

Star System. The way in which studios groom stars under contract.

Star Vehicle. A film produced for the purpose of showing off the talents of a performer.

Star. A well known actor, director, etc.

Static Shot. A motionless shot.

Steadicam. A lightweight camera mount producing steady, smooth, handheld shots.

Steadicam Operator. A skilled camera operator specializing in operating a Steadicam.

Steenbeck. A Flatbed.

Stem. A separate audio output for a group of tracks.

Stereo. Two-channel (left and right) audio track.

Stereotyping. The act of portraying a character in offensive or distorted way.

Still Photographer. A person who photographs single stills on set to be used by the publicist.

Still. A single image.

Stinger. (1) A short piece of music used for underlining sudden dramatic events. (2) A professional quality extension cord.

Stock Character. A minor character whose actions are completely predictable or stereotypical.

Stock Footage. Royalty free, pre-recorded footage that can be licensed for use in other films. Commonly used in documentaries.

Stock Music. Music not written specifically for the film in question, often licensed for use in the production.

Stock. Unexposed film.

Stop date. The last date on which a performer is legally obligated to work.

Stop Frame. See Freeze Frame.

Storage Card. A memory storage device used to store data. (CF, SD, SSD, SmartMedia, etc.)

Story. The events that appear in a film.

Storyboard. A sequence of drawings and illustrators with some directions and dialogue, representing the shots planned for a movie.

Storyliner. Responsible for creating the plot twists for a given story line.

Strike. The process of breaking down a camera position, location or set.

Stripe. 35mm mag stock.

Studio Chief. The person who has the final authority for each film project.

Studio System. (1) The studio "assembly-line" used to mass produce feature films from the 1920s until the late 1950s. (2) The metadata system used by Baseline Syndication, a provider of film and television metadata information. See Metadata.

Studio. (1) A company that specialize in developing, financing and distributing feature films. (2) A site used for a film production, with physical sets, stages, offices, backlots, etc.

Stunt Coordinator. A person who arranges and plans stunts.

Stunt Coordinator. Responsible for arranging the casting and performance of stunts.

Stunt Double. A stunt performer used to replace an actor when the scene calls for a dangerous or risky action.

Stunt. A dangerous piece of physical action performed by a stunt performer.

Stylized. The artificial exaggeration or elimination of details in order to deliberately create an effect.

Subplot. A secondary plot line, often complementary but independent from the main plot.

Subtext. The unexpressed "real" meanings of a character's spoken lines or actions.

Subtitles. Captions displayed at the bottom of the screen to translate or transcribe the dialogue or narrative.

Sundance. The Sundance Film Festival.

Super 16. A single-perforated, motion picture film that uses the maximum image area available on conventional 16 mm film.

Super Speed. A fast prime lens, typically with a T-stop of 1.3.

Superimpose. To place one shot, text or image on top of another on the same piece of film stock.

Supervising Sound Editor. A chief sound editor.

Supporting Feature. The feature presentation. See Double Bill.

Supporting role. A role by a supporting actor in a film below that of a lead role, and above that of a bit parts.

Surreal. A term applied to a film expressed by a random, non-sequential juxtaposition of shots that go beyond realism. *(The Beyond {1981}, The Blood of a Poet {1930}, The Seashell And The Clergyman {1928}, etc.)*

Surround Sound. A sound system which creates the illusion of multi-directional sound through speaker placement above or behind the audience.

Suspenser, Thriller. A genre that uses suspense and tension as its main elements. *(Psycho {1960}, The Silence of the Lambs {1988}, The Sixth Sense {1999}, Black Swan {2010}, etc.)*

Sustain. The amplitude of a sound or musical note while it is being held.

Swashbuckler. Adventure films with an heroic, athletic, sword-wielding character. *(The Three Musketeers {2011}, Pirates of the Caribbean {2003-2011}, The Legend of Zorro {2005}, etc.)*

Sweeten. Enhancing the sound of a recording or sound effect with equalization or another signal processing device.

Swing Gang. One or more persons who make last-minute changes on a film set.

Sword and Sorcery. A class of fantasy movies characterized by the presence of wizards and warriors, magic and sword fighting. *(Jack the Giant Slayer {2013}, Barbarian {2003}, The Warrior and the Sorceress {1984}, etc.)*

Sword-and-Sandal Epic, Peplum Film. A genre of largely Italian-made historical or biblical epics, popular during the 60's. *(Hercules Unchained {1959}, Maciste in Hell {1925}, etc.)*

Symbol. An object in a film that stands for an idea.

Symmetry. When one side of the frame balances out or mirrors the other.

Sync Mark. The point at which the clapsticks come together after a slate is called.

Sync Sound. Sound recorded while shooting picture.

Sync. The degree to which sound and picture are lined up. Syncing is the process of matching sound and picture before editing.

Synching Dailies. Assembling, for synchronous interlock, the picture and sound workprints of a day's shooting.

Syndication. The sale of the right to broadcast television programs by multiple television and radio stations, without going through a broadcast network, though the process of syndication may conjure up structures like those of a network itself, by its very nature. *

Synopsis. A short summary of the major plot points and characters of a script.

System Administrator. A person employed to maintain and operate a computer system or network.

T-Stop. A more accurate measurement of light passing through a lens than the commonly used F-Stop.

Tachometer. On-camera measurement of the film speed while the camera is running.

Tag Line. A short, memorable line used to characterize a film in marketing, typically used in posters, trailers and commercials.

Tail leader. A leader used at the end of a strip to indicate the end of a reel.

Tail Slate. A phrase used when marketing a shot with a clapper after the content was shot as opposed to the beginning. The clapper will usually hold the slate upside down and say "Tail Slate".

Tail. The end of a shot or a roll.

Take Down. Using nets, scrims and dimmers to reduce light.

Take. Multiple versions of the same shot until the director is satisfied with the work and approves the take.

Talent. Anyone appearing on-camera.

Talkie. The common term used for films made with spoken dialogue in the late 1920's.

Talking Heads. A medium shot (neck up) of a person talking.

Tap. A monitor connected to the camera.

Tape Grade. Color correction performed from a master tape.

Tape Recorder Operator. A sound crew member responsible for operating and maintaining tape-based recording equipment on set.

Tearjerker. A term referring to a tragic or very sad film. Contrast to feel-good film. *(The Notebook {2004}, Schindler's List {1993}, The Green Mile {1999}, etc.)*

Teaser Trailer. A short version of the trailer.

Technical Advisor, Consultant. A credit given to any specialists with high expertise in any particular field who provides technical advice.

Technical Grade. A telecine transfer adjusted to be as flat as possible so as not to lose any color information.

Technicolor. A well known color film process invented in 1916. It is also the name of the corporation itself, offering different high-end services to filmmakers.

Telecine Colorist. Responsible for a Telecine Grade. See Color Grading, Telecine.

Telecine. A machine for scanning and transferring motion picture film to a digital format in real time.

Telephoto Lens. A long-focus lens in which the physical length of the lens is shorter than the focal length. It allows the operator to bring distant objects closer and is especially common in wildlife photography.*

Teleplay. A script written for a television production.

Television Movie. A feature-length film produced for a TV premiere, often funded by a TV network.

Television Rights. A right granted to a distributor to broadcast the content on television.

Television Series Pilot. The first of a series of TV shows produced to gain audience feedback.

Television Special. A television production of a singular event.

Television Spot. A short TV advertisement space.

Telewriter. A writer who creates teleplays.

Temp Dub. The first round of mixing dialogue, music, and sound effects.

Temperature. The measurement of light and the color emitted by its temperature.

Tenner. A common 10K lighting unit.

Tentpole. A film or series of films consistently producing high revenues to a distributor or a studio. See Cash-Cow. *(Avatar, The Avengers, Harry Potter, Iron Man, Transformers)*

Terra-Flite. A cross between a steadicam and a louma crane.

The Call. The various directions spoken by the director to begin a take. *(e.g. "Roll Sound!" "Roll Camera!" "Mark it!" "And... Action!")*

The Industry. Another name for the film or entertainment business.

The Slate. Another name for a clapper-board.

The Sticks. (1) Tripod or the tripod legs. (2) The clapper-board.

Theatre. The facility where a film is screened, presented or viewed.

Theatrical Rights. A right granted to a distributor to give the film a limited or wide release in cinemas.

Theatrical. A slang term referring to a theatrical release.

Theme Music. The dominating signature score in a motion picture, often it is the opening or closing music.

Theme. The central characteristic in a film.

Thin raster. An image squeezed to preserve bandwidth and then unsqueezed for playback.

Three shot. A medium shot framing three people.

Thumbnails. Small images used to reference clips on the camera or the editing station.

THX. A high-end theatrical film exhibition sound system.

Tie In. A cross-promotion venture.

TIFF. Tagged Image File Format popular for delivering sequence shots for VFX.

Tight On. A close-up shot of a subject.

Tilt shot. A vertical camera movement on a fixed horizontal axis. Also known as tilt pan, tilt up or tilt down.

Time Base Signal. A signal recorded for synchronizing film and sound workprints.

Time Code. Electronic guide track providing an accurate time reference and sync for editing.

Time Lapse. Capturing a series of frames over a period of time to create the illusion of speed. When played back at normal speed, slow action (like the movement of clouds) appears to be occurring much faster than it would in real life.

Timed Print. A print where the timer has gone through and timed every shot.

Timeline. The representation of time. It is a common interface in non-linear video editing systems and is where video clips are placed to create an edit.

Timer. A lab technician responsible for timing the film for the best possible prints.

Timing Report. A list of notes created by the timer.

Tint. The use of inserting a dominant color to a clip for the purpose of changing the scene's mood, look or feel.

Title Design. The process of designing or animating the titles and the way they appear on screen.

Titles. The lines of text or words that appear on the screen to convey information. *(This includes credit titles, opening titles, end titles, insert titles and subtitles.)*

Tix. Abbreviation for tickets

Tonal Range. The number of available tones a digital image has to describe the dynamic range. See Gamut.

Tone. The mood or atmosphere of a film scene.

Toon. Abbreviation for cartoon.

Topline. To place a cast-member's name before the title on the credits and promotional items.

Tour De Force. A highly skillful performance by a lead actor.

Track. A single audio component or channel.

Tracking Shot. A dolly shot moving alongside a moving subject.

Trademark. A highly recognized, personal touch or style of an actor, director, writer or producer.

Trades. The collective name used to refer to professional trade magazines in the entertainment industry.

Trailer. A preview composed of short excerpts and scenes from an upcoming film, used in advertising and marketing.

Trainer. A person responsible for training performance animals.

Transition. A style of gradually changing from one shot to the other by using a "transition effect" such as a fade, dissolve, wipe, etc.

Transportation Coordinator. Responsible for managing and coordinating the transportation of cast, crew, and equipment during filming.

Trash Film. A low-budget film created to repel the audience by showing extremely gory shots or extremely infantile humor. Also called a 'Turkey Film'. *(Braindead {1992}, Re-Animator {1985}, Bad Taste {1987}, Zombie Flesh Eaters {1979}, etc.)*

Travelling Matte Shot. A matte shot requiring intense masking since the object is constantly in motion.

Travelogue. A film that shows scenes from foreign, exotic places. *(Midnight in Paris {2011}, The Darjeeling Limited {2007}, Up {2009}, The Secret Life of Walter Mitty {2013}, etc.)*

Treatment. A detailed literary summary of the film's script consisting of a detailed summary of action and characters in the film. Often used to market and/or sell a film project or script

Trilogy. A series of three movies closely connected by a single plot. *(e.g. The Lord of the Rings, Harry Potter, Pirates of the Caribbean)*

Trim Bin or Editing Bin or Bin. A bin on wheels in which the film is hung while editing.

Trims. Short portions of scene-leftovers (usually a foot or less) stored in their own vault box or in a trim book.

Triple Threat. An actor or actress who can either sing, dance and act or act, direct and write.

Tripod Head. The top portion part of the tripod to which the camera is mounted.

Tripod. A support or stand for a camera, telescope, etc.

Trombone. A device used for suspending lights from set walls.

TTL, Through The Lens. A feature which measures light levels in a scene through the camera's lens, as opposed to a separate metering window.

Tungsten. The color temperature of artificial light, 3,200K.

Turnaround. A state of limbo a film enters after being abandoned by a studio and is no longer in consideration for a production.

Turret. A rotating lens mount allowing for the mounting of additional lenses on a camera.

Twist Ending, Ending Twist. A surprising and often unexpected ending to a film.

Two-Hander. A film with only two characters. *(Hard Candy {2005}, Before Sunrise {1995}, etc.)*

Two-Reeler. A film lasting a little over 20 minutes

Two-Shot. A medium close-up shot of two subjects, usually framed from the chest up.

Typecasting. When an actor/actress is commonly associated with a 'stereotyped' casting role.

Ultrasonic Cleaner. A cleaning device used to clean film before printing or transferring to video.

Ultrasonic Splicer. An advanced splicing machine using ultrasonic signal to melt the film together.

Ultra-Bounce. A highly versatile, lightweight fabric providing a soft bounce light.

U-matic. An outdated analog recording videocassette format.

Uncredited Role. A role for a semi-influential character played by a major or minor star for which they do not receive credit. *(e.g. Bruce Willis in Four Rooms.)*

Underacting. A genuine, unnoticeable acting performance as oppose to overacting.

Undercrank. The slowing-down of a camera's frame rates to produce faster motion.

Underexposed, Underexposure. The opposite of overexposed. An underexposed picture is the result of not enough light entering the sensor. Underexposure can cause an indistinct, dimly-lit, unclear and often noisy image.

Underground Film. A low-budget film created without funding, distribution or support of any kind. *(The Last Broadcast {1998}, Clerks {1994}, Living In Oblivion {1995}, etc.)*

Underscan. A mode in cameras and monitors allowing full-view of the screen, including cropped portions.

Underscore. Emotional or atmospheric music running underneath a dialog or narration.

Unions. Professional organizations representing creative and technical members of the motion picture industry.

Unit Production Manager, UPM. The top staff position responsible for administrating and managing the production.

Unit Publicist. A member of the Publicity Department responsible for press and media exposure, reporting to the Publicity Director.

Unspool. To screen or show a film.

Unsqueezed Print. A corrected Anamorphic print.

Up-conversion. Converting SD footage to HD format.

Upright Moviola, Upright. A revolutionary editing device invented in 1924. It was the first motion picture editing workstation that allowed the editor to actually study the shots and view the footage while editing.

Utility Person. An assistant responsible for various manual tasks on-set.

Utility Sound Technician. A member of the sound department, most often in charge of pulling cables and dealing with technical audio issues on-set.

Vamp. A sexually alluring character (woman), typically a heartless, man-eating seductress. *(Jennifer in Jennifer's Body, Sil in Species, Satanico Pendemonium in From Dusk Till Dawn, Grendel's Mother in Beowulf.)*

Variac. A voltage altering simmer.

Variety. A respected entertainment-trade magazine.

VariSpeed, Pitch Control. Effect where the speed of the camera is changed mid-shot.

Vault Box. A box designed to store film rolls.

VCR. A Video-Cassette Recorder.

Vertical Interval, Vertical Blanking Interval, VBI. The time difference between the final line of one frame and the beginning of the next.

Vertigo Effect, Dolly Zoom. A technique created by Alfred Hitchcock during his film Vertigo. In the shot, the camera tracks backwards while simultaneously zooming in, distorting the background while keeping the subject in place.

Video Assist. A system of monitors, recorders and transmitters allowing the director and cinematographer a view of the shot as it is being filmed. (See Video Village)

Video Cassette Recorder. A device for recording and playing prerecorded video tapes.

Video Village. A specific area where video monitors are placed for the director to oversee the framing, focus and overall quality of the shot.

Video. An analog or digital visual image.

Videographer. Another name for camera operator. When the two are credited separately, it is generally referring to the person in-charge of handling video cameras on-set.

Viewfinder. What the camera operator looks at to control the frame, focus, and motion of the camera. Could be a direct-optical, EVF or LCD screen, among others.

Vigilante Picture, Revenge Film. An action film genre. *(Oldboy {2003}, Taken {2008}, Kill Bill {2003}, City of God {2002}, etc.)*

Vignette. A masking device use to darken the edges of a frame and direct the eye to the center of the frame.

Vimeo: A popular video-sharing website among indie filmmakers.

Vistavision. A high-quality, widescreen 35mm film format with relatively low noise and grain.

Visual Effects Creative Director. A person responsible for directing and supervising the film's visual effects.

Visual Effects Editor. An artist working to incorporate visual effects into live-action sequences and preparing them for review by the Visual Effects Supervisor.

Visual Effects Producer. A person responsible for breaking down the script and advising the director as to how to shoot the live-action footage, often known as "the plate".

Visual Effects Rigger. A VFX crew-member working to prepare animation rigs for characters. Not to be confused with Special Effects Rigger.

Visual Effects Supervisor. The supervisor in-charge of the VFX department and crew, oversee-ing all aspects of the VFX process.

Visual Effects. Commonly refers to all digital post production alternations made to the film's image, regardless of how complex or simple they may be. (From removing a boom microphone in a shot to integrating complicated CGI footage with live-action sequences).

VITC, Vertical Interval Time Code. A type of SMPTE timecode embedded as a pair of black-and-white bars in a video signal.*

VO. Voice-over.

Voice-Over Artist. A voice actor recording the voices necessary to create a voice-over.

Voice-Over, VO. The recorded narration or dia-log playing over the action on-screen.

VU Meter, Volume Unit Meter. A device de-signed to measure signal levels in audio equip-ment.

W

Walkie Check. See Radio Check.

Walk-On. A brief, minor role in a film or show, usually with no lines of dialogue.

Walk-Through. The first rehearsal on-set.

Walla. A murmur sound effect, used to establish a crowd of people on location.

Wardrobe Department. Crew-members responsible for costumes. See Costume Design.

Wardrobe Supervisor. The head of the Wardrobe Department.

Wardrobe. The common term for the Wardrobe Department.

Waveform Monitor. An oscilloscope used to measure and monitor video or audio levels.

Weapons Master, Armourer. One who specializes in weapons, armors and firearms. See Armourer.

Wedges. Wood wedges used for leveling and stabilizing.

Western Dolly. A plywood dolly used as a camera dolly for smooth surfaces.

Wet-Gate. A process of removing dust, dirt and hair off the film.

Whip Pan. A very fast pan.

White Balance, WB, Color Balance. The camera's ability to automatically correct color cast, adjusting its settings to reinterpret the color white. See Color Balance.

White Noise. A random signal with a consistent amount of energy per-hertz.

Whodunit, Who Done It. A mystery / detective film genre. *(Angels & Demons {2009}, Basic {2003}, Love Crime {2010}, A Perfect Murder {1998}, The Gift {2000}, etc.)*

Whoop-Whoops. Any effect or additional noise added to a sound to make it sound more attractive.

Wide Lens. A lens with a focal length smaller than that of a normal lens, they capture a wider shot of the scene. 16mm, 25mm, 35mm and 50mm lenses can be considered wide.

Wide-Angle Shot, WS. A shot captured with a wide-angle lens.

Widescreen. Any aspect radio greater than 4.3 (1.33:1) in which the image is significantly wider than it is tall.

Wild Line, Wild Sound, Wild Track. A non-synched sound, recorded separately without picture to supplement sync takes. Generally referring to a line of dialogue,

Wilhelm Scream. A distinctive scream archived by Warner Brothers and used repeatedly on countless films. *(Star Wars, Kill Bill, etc.)*

Wipe. A commonly used "push" transitional effect.

Word of Mouth. An important element in film marketing, also see Buzz and Viral Video.

Workprint. A positive duplicate of the original negative.

Workstation. Any audio/video recording and editing system.

Wow and Flutter. The measurement of 'frequency wobble', a playback irregularity caused by recording speed fluctuations.

Wow. Pitch variations in recording and playback.

Wrangler, Animal handler. A person or animal trainer responsible for the care and handling of all non-humans on set.

Wrap!, It's a Wrap!. To finish shooting at the end of the day. Can be also used to describe the end of a shot, scene or the entire film.

Writer. The person(s) responsible for writing the work, be it a novel, script or screenplay.

Writers Guild of America. A labor union representing film, television, radio, and new media writers.

X. Abbreviation of "cross".

X-Y Pattern. A stereo-mic structure that uses two microphones placed and aimed in crossed directions which feed two channels for stereo pickup.

XD Cards. A small memory card format used in older digital cameras.

Xenon. A very bright, daylight balanced lamp.

XLR Connector: A standard sound connector used in professional audio.

YMC. Used to refer to Yellow, Magenta, and Cyan.

Yarn. Slang for an fabricated story.

Yawner. A term used to describe a boring film

YUV. A color space used in NTSC and PAL broadcast video systems.

Zero Cut. A method of cutting negative for blow up.

Zero Cut. A method of preparing A and B rolls for print.

Z-Movie. A very low-budget film produced without consideration for production value.

Zoom Lens. A variable focal length lens.

Zoom Shot. A shot taken with a variable focal length lens, in which the image rapidly grows larger or smaller as the process of zooming itself is captured. This is in contrast to a Close-Up Shot where the camera rolls after the frame had been established.

Zoopraxis. An early movie process for creating animated projections.

Zoptic Special Effects. A camera system (Also known as Front Projection Effect) used before the popularization of CGI and computer-based graphics. First introduced on the 1978 Superman and developed by Zoran Perisic.

Made in the USA
Middletown, DE
16 September 2016